The **LOOK** *of* **LOVE**

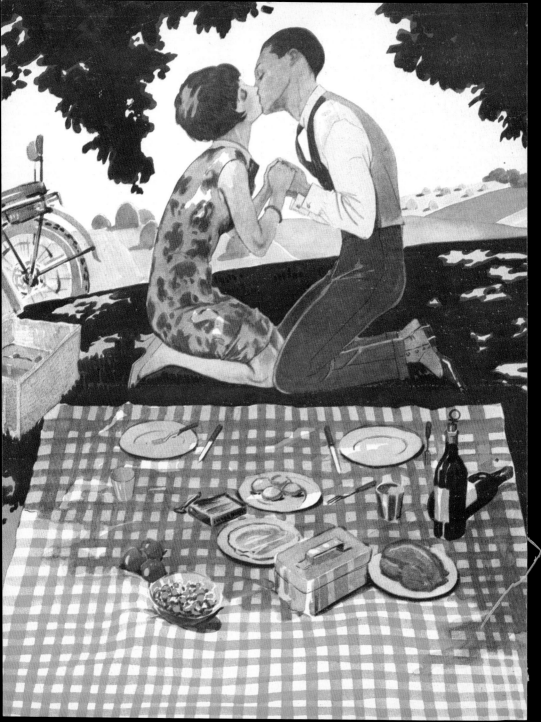

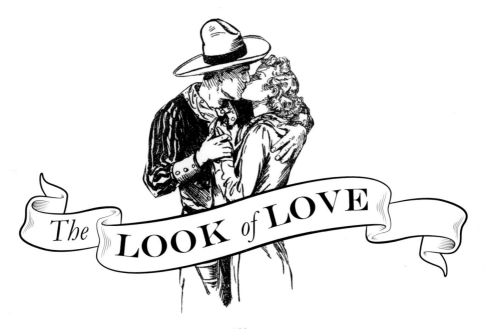

The LOOK of LOVE

Romantic Illustration
through the Ages

THE BRITISH LIBRARY

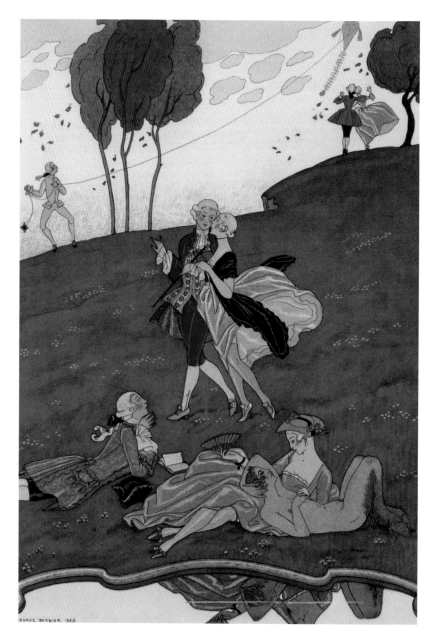

Illustration by Georges Barbier from *Fêtes galantes* by Paul Verlaine, 1928

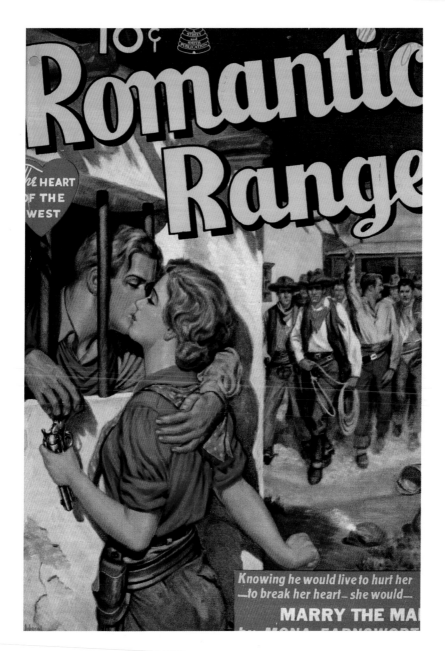

Romantic Range magazine, November 1937

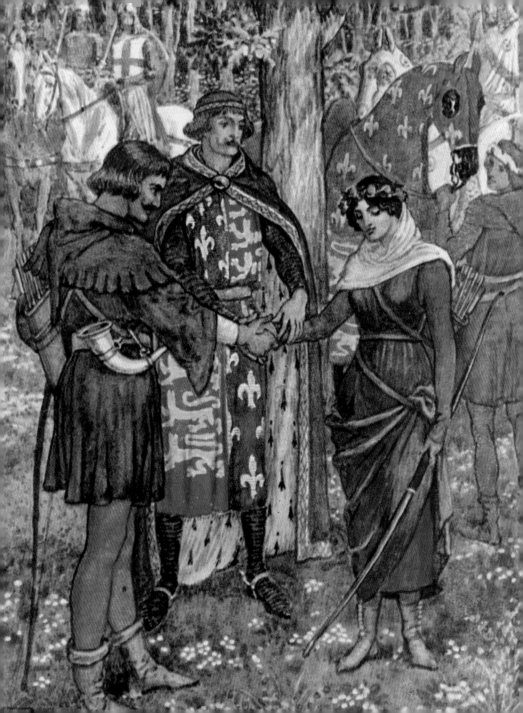

'Unable are the loved to die.
For love is immortality.'

Emily Dickinson

In Fairy Land: A Series of Pictures from the Elf-World by Richard Doyle, 1870

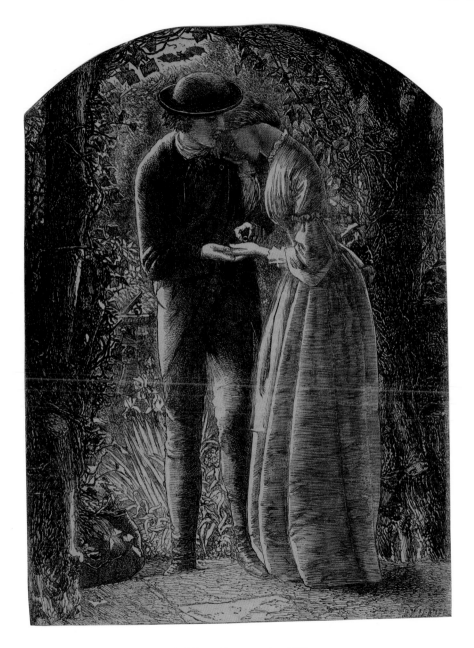

The Welcome Guest magazine, 1858

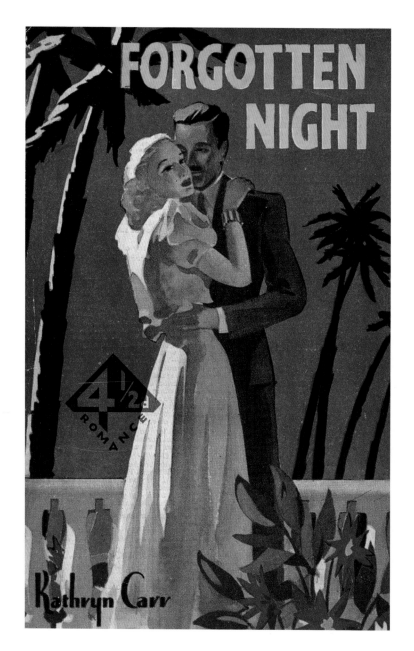

Forgotten Night, romance novel, 1950

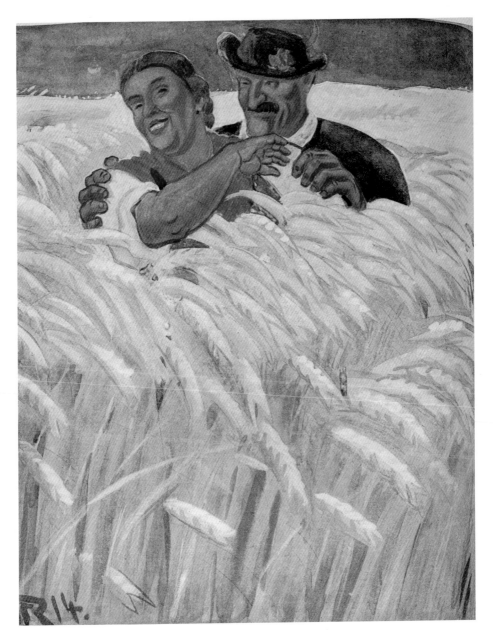

Jugend magazine, 1904

'You don't love someone for their looks, or their clothes, or for their fancy car, but because they sing a song only you can hear.'

Oscar Wilde

Souvenir programme for *Gaiety Girl* at Dolly's Theatre, London, 5 June 1899

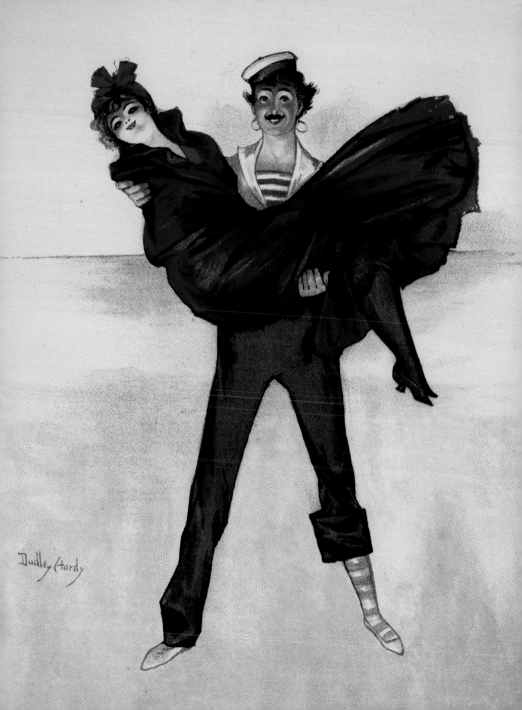

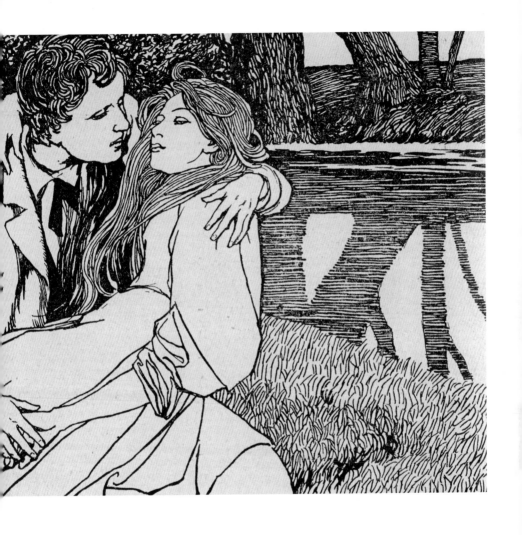

Jugend magazine, 1896

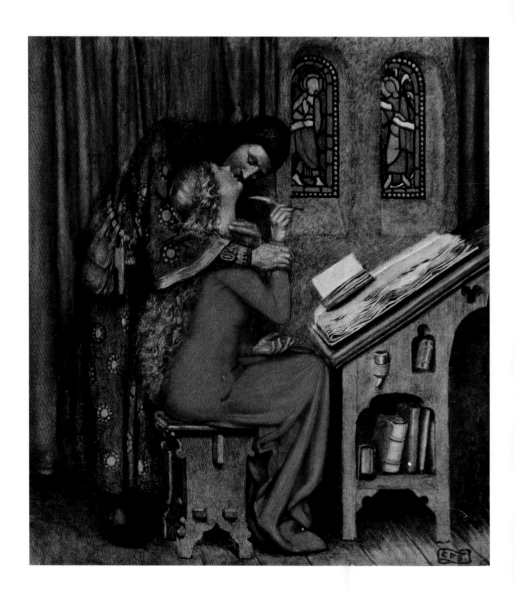

Abelard and Héloïse by Eleanor Fortescue Brickdale, 1919

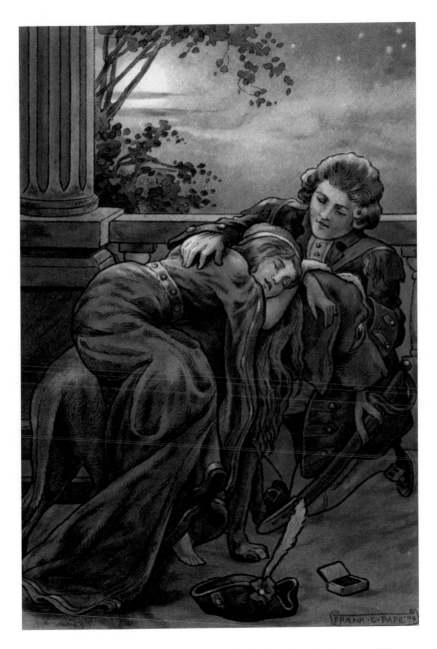

The Tinderbox by Franck C. Pape in *Fairy Tales* by Hans Christian Andersen, 1910

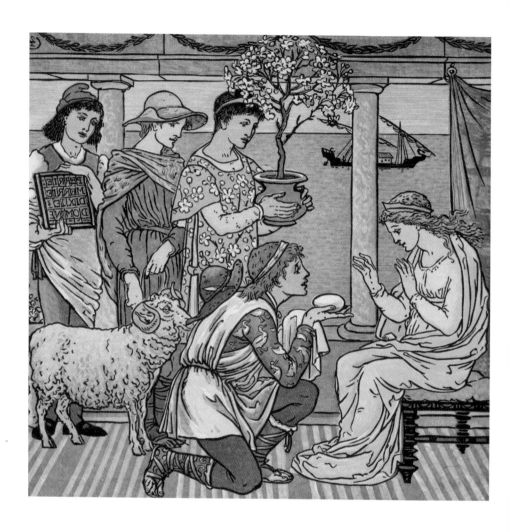

The Baby's Opera by Walter Crane, 1899

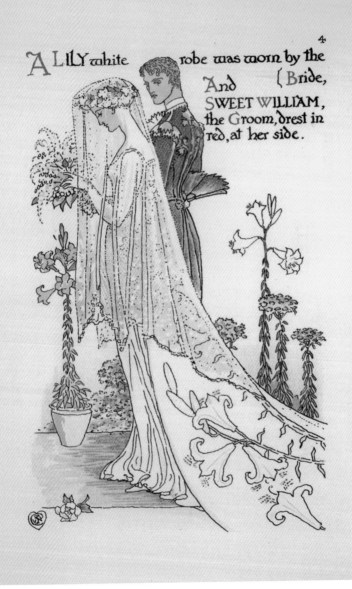

A LILY white robe was worn by the Bride, [4]
And SWEET WILLIAM, the Groom, drest in red, at her side.

A Flower Wedding by Walter Crane, 1905

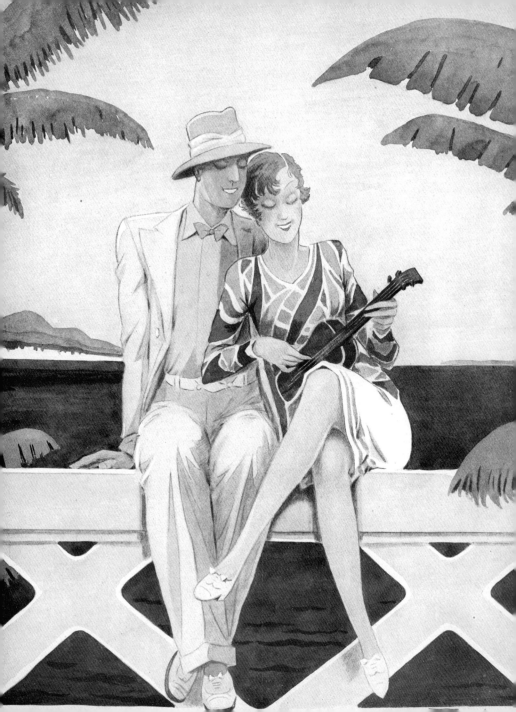

'Earth's the right place for love.
I don't know where it's likely to go better.'

Robert Frost

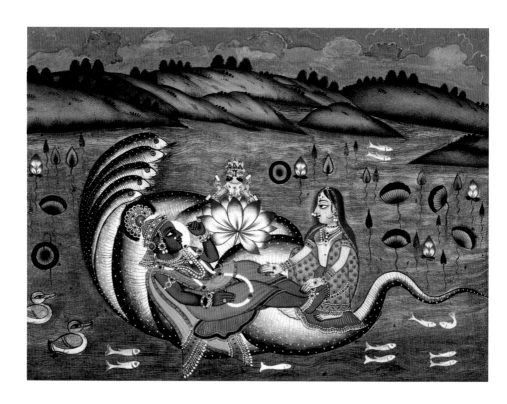

Vishnu and Lakshmi, from the *Bhagavatapurana*, 1806

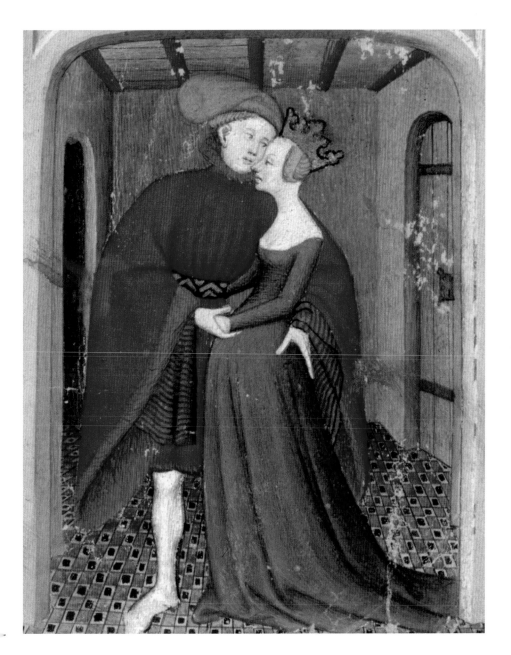

The Book of the Queen by Christine de Pisan, *c.* 1410–14

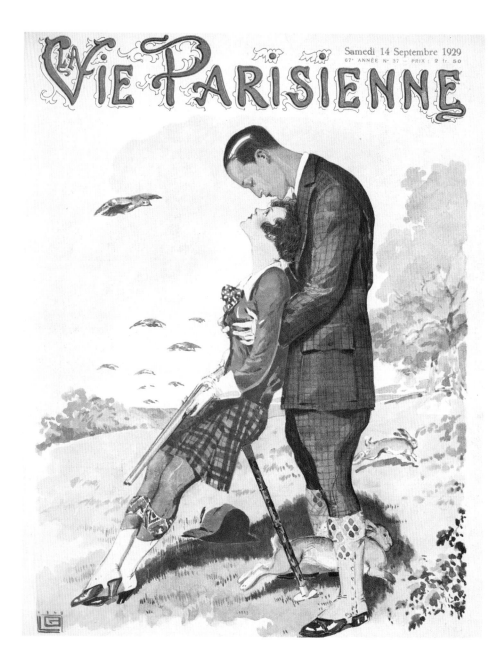

La vie parisienne, 14 September 1929

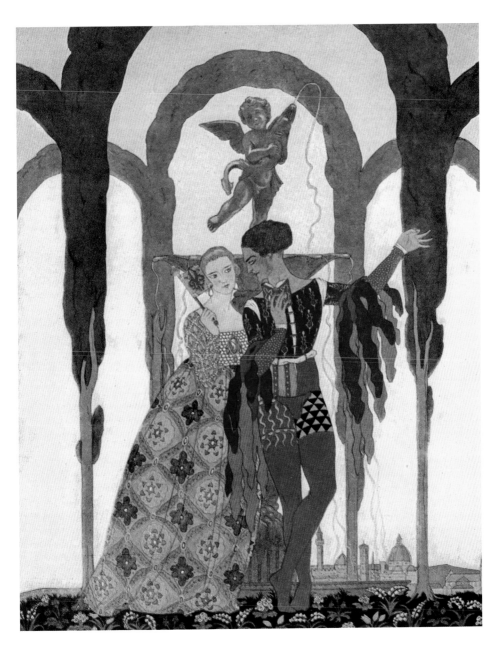

Image by Georges Barbier from *L'Illustration*, 25 December 1921

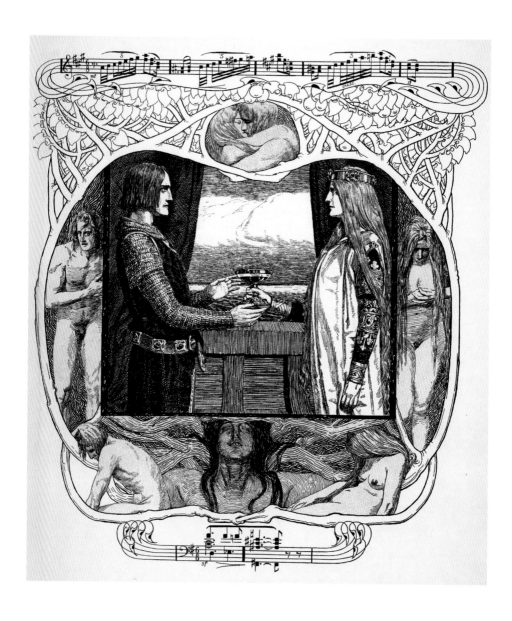

Richard Wagner's *Tristan and Isolde*, illustrated by Franz Stassen, 1880

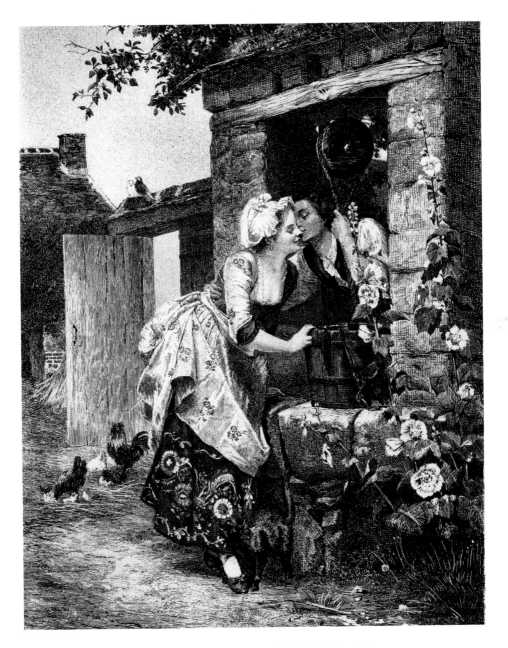

Cover of the score of *Flirt Polka* by Frederic Rysler, 1879

'The war between the sexes is the only one in which both sides regularly sleep with the enemy.'

Quentin Crisp

Price 3ᵈ

Vanity Fair
& Hearth & Home.

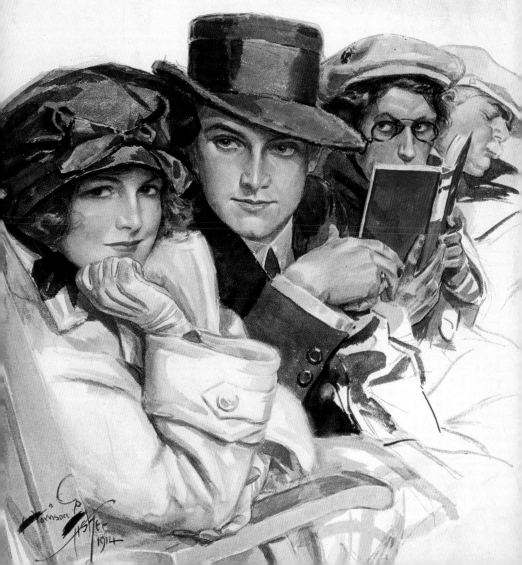

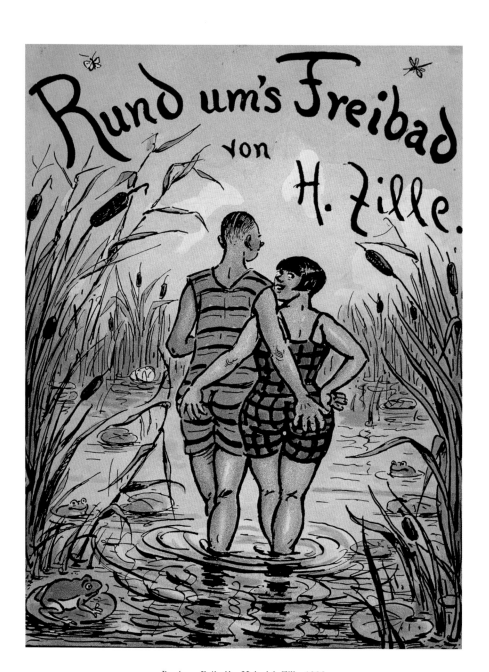

Rund ums Freibad by Heinrich Zille, 1926

Jugend magazine, 1914

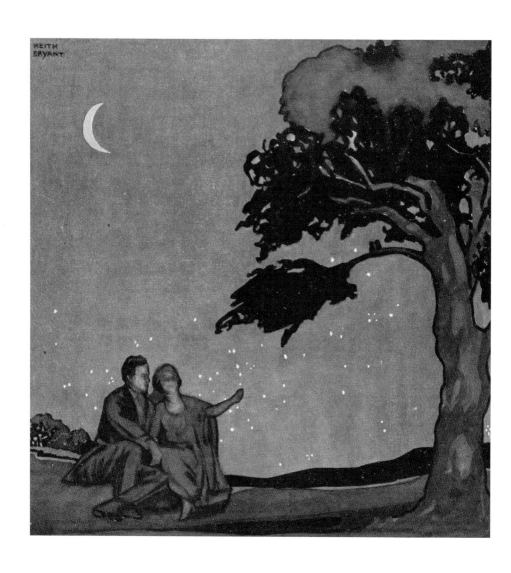

Whispering Waltz by John Schonberger, *c.* 1920

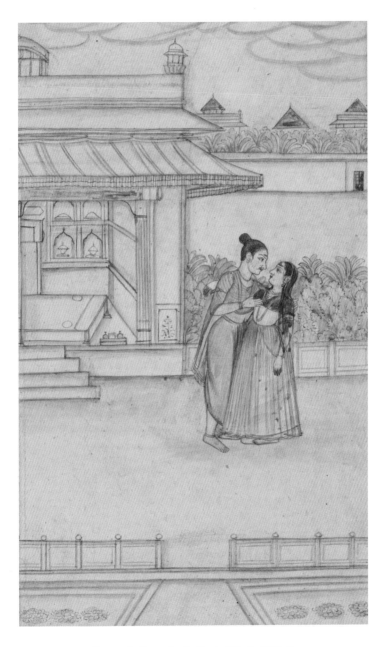

Ragamala illustration by Govind Singh, 1780–2

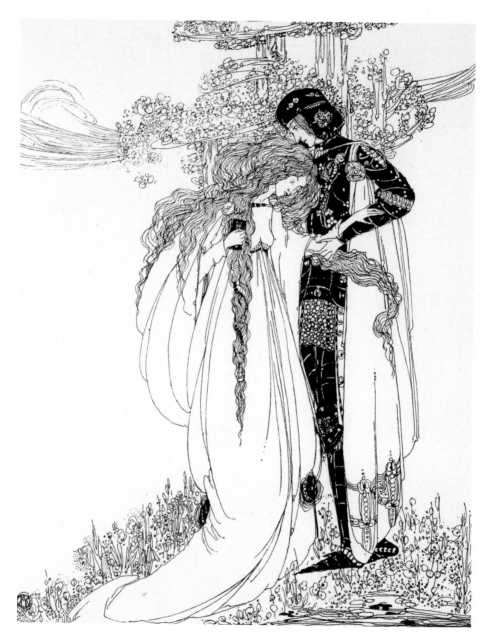

Illustration by Jessie M. King from *The Defence of Guenevere and Other Poems* by William Morris, 1904

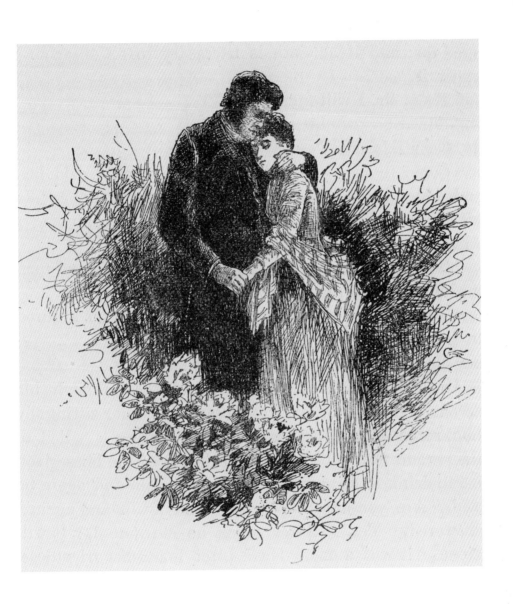

Jane Eyre and Mr Rochester, by Edmund H. Garrett from *Jane Eyre*, 1897

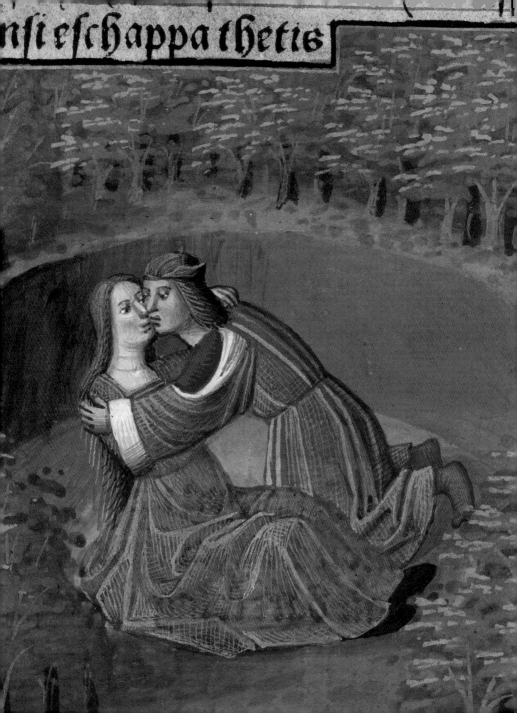

'Extinguish my eyes, I'll go on seeing you
Seal my ears, I'll go on hearing you
And without my feet I can make my way to you
Without a mouth I can swear your name.'

Rainer Maria Rilke

Peleus and Thetis from a fifteenth-century manuscript of Ovid's *Metamorphoses*

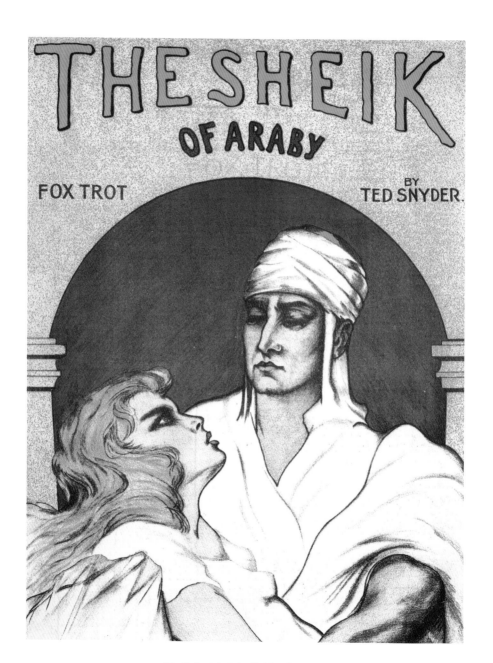

The Sheik of Araby by Ted Snyder, 1921

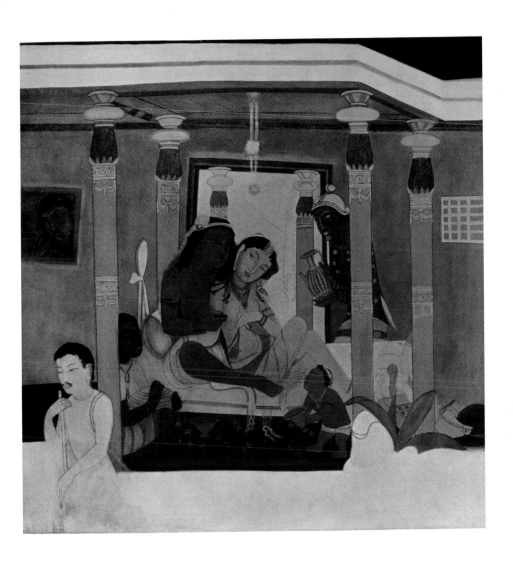

Copy of a fresco from the Ajanta caves, India

In Fairy Land: A Series of Pictures from the Elf-World by Richard Doyle, 1870

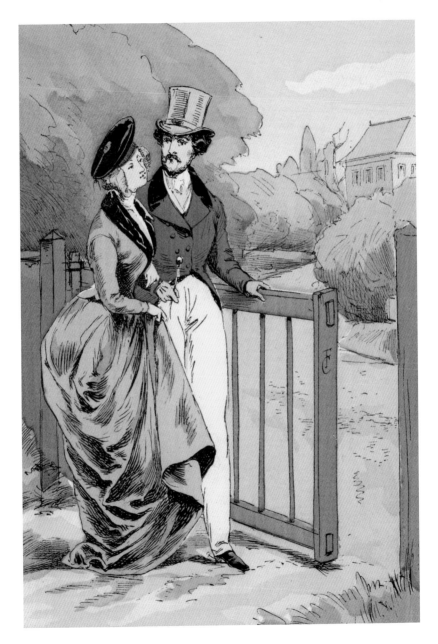

A Sentimental Walk by F. Courboin from *Fashion in Paris* by Octave Uzanne, 1898

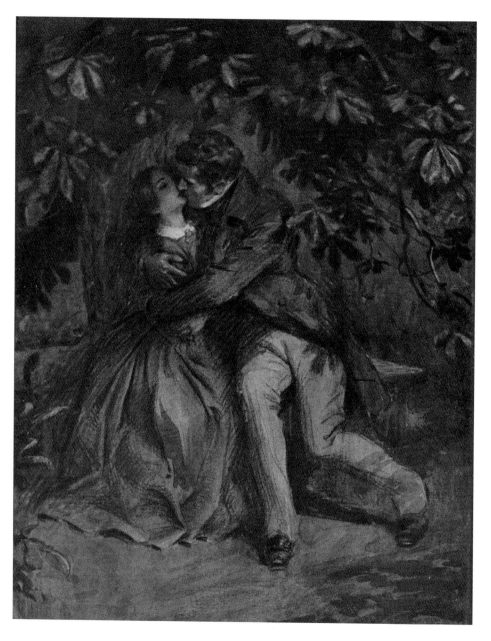

Mr Rochester and Jane Eyre by C. E. Brock from *A Day with Charlotte Brontë* by May Byron, 1911

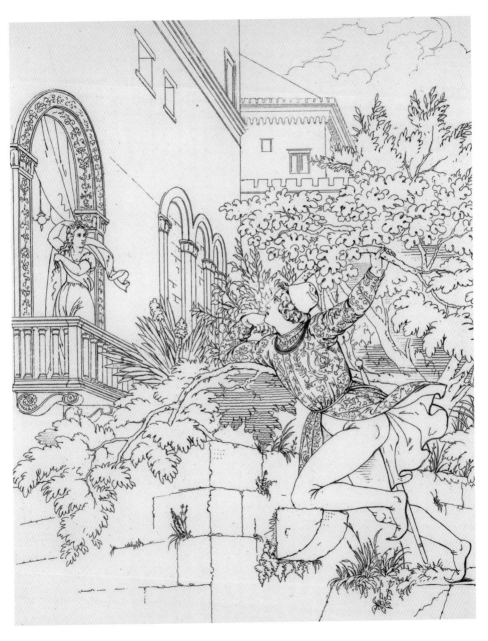

Romeo and Juliet from *Sketches to Shakespeare's Plays* by L. S. Ruhl, 1838–40

'I have for the first time found what I can truly love – I have found you.'

Charlotte Brontë, *Jane Eyre*

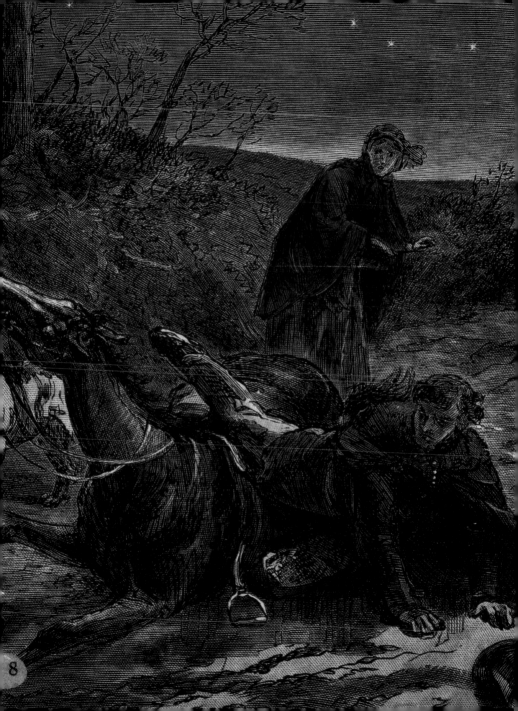

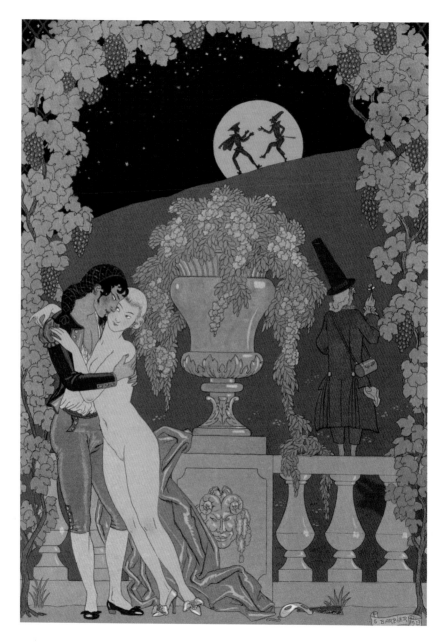

Illustration by Georges Barbier in *Fêtes galantes* by Paul Verlaine, 1928

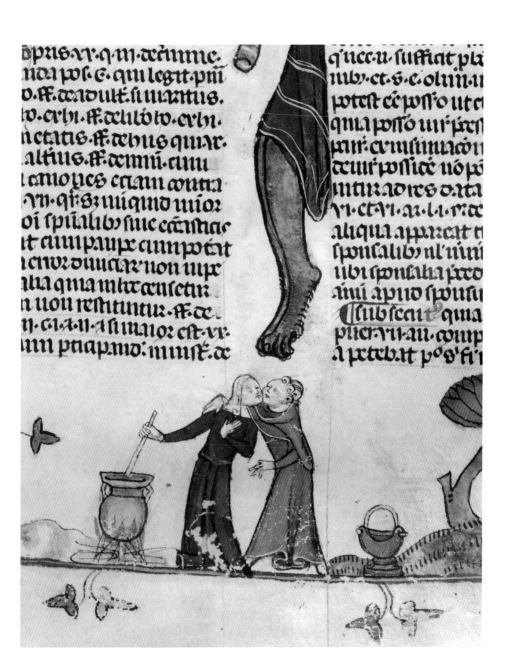

Smithfield Decretals, late thirteenth-century manuscript

"Their lips were four red roses on a stalk,
Which in their summer beauty kissed each other"

Richard III., Act iv. Sc. 3

18.

Illustration by Walter Crane from *Flowers from Shakespeare's Garden*, 1905

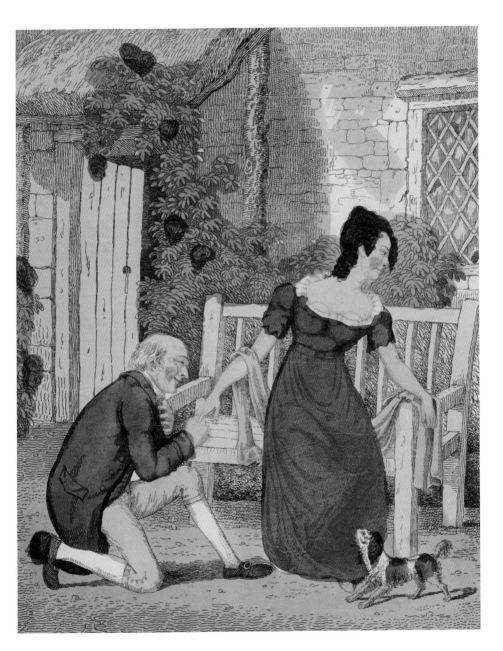

Victorian valentine's card, *c.* 1845–50

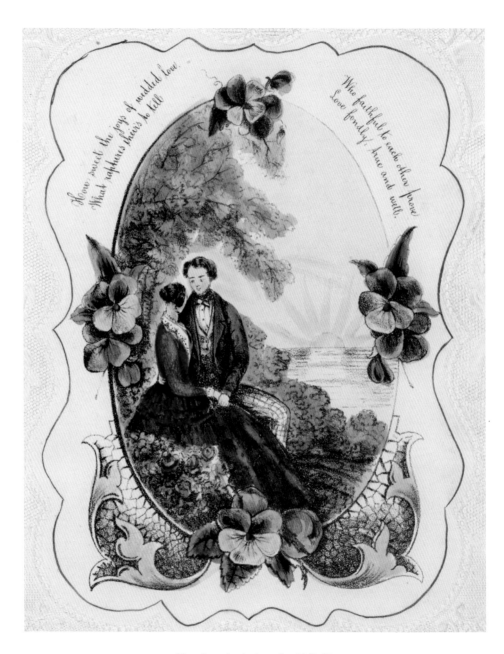

How sweet the joys of wedded love,
What raptures theirs to tell

Who faithful to each other prove
Love fondly, true and well.

Victorian valentine's card, *c.* 1845–50

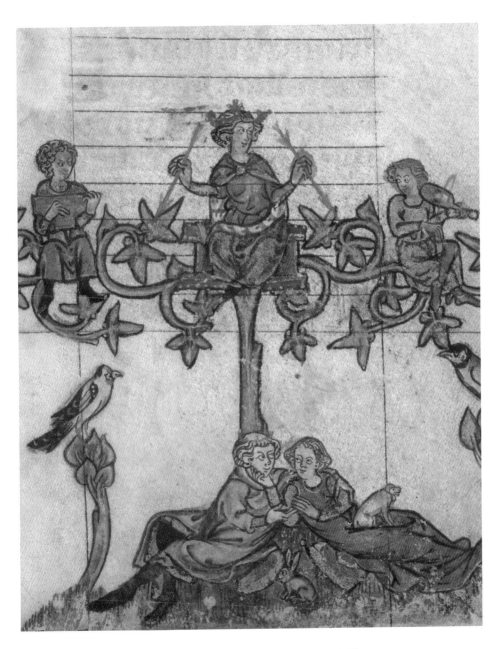

The King of Love from a Book of Hours, 1310–20

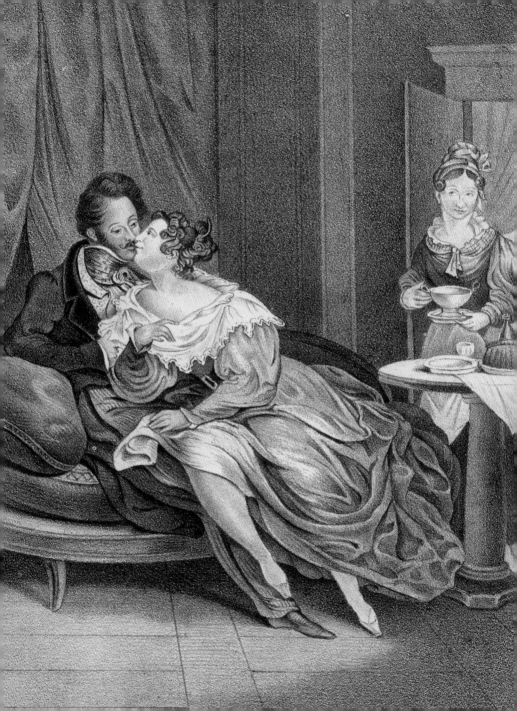

'Whoever named it necking was
a poor judge of anatomy.'

Groucho Marx

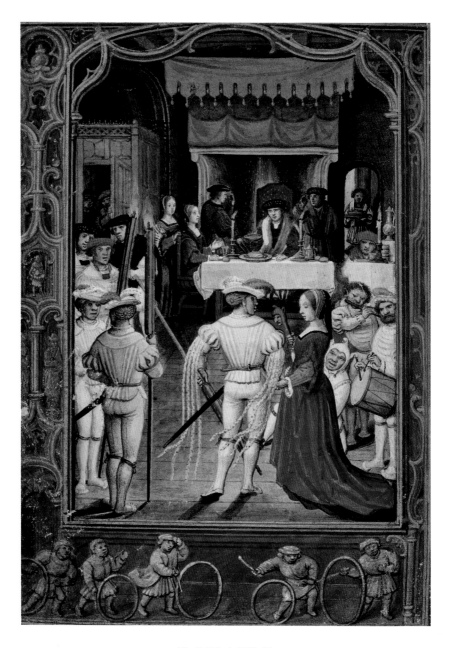

The Golf Book, 1520–30

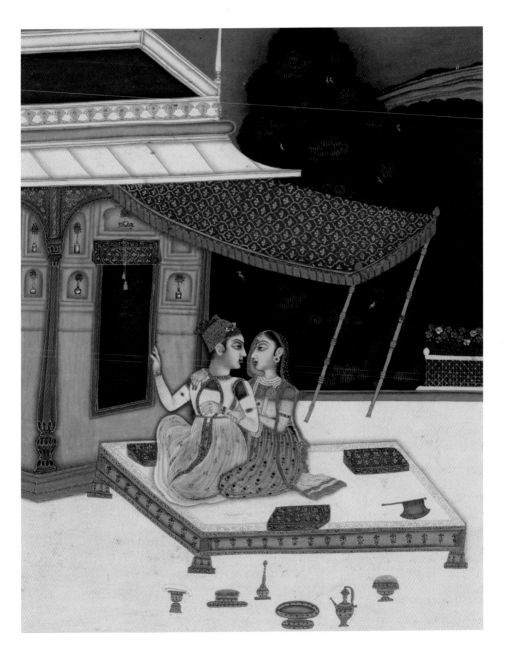

Ragamala illustration, *c.* 1760

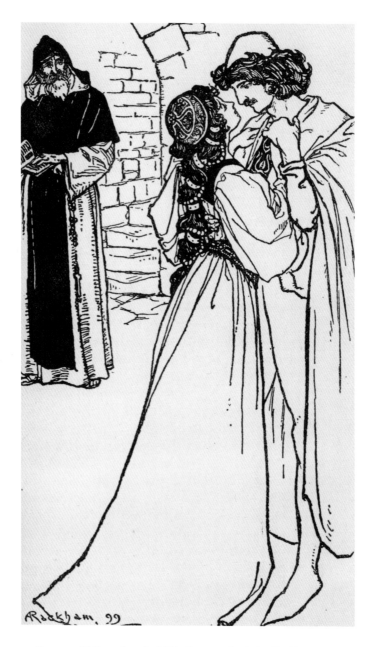

Romeo and Juliet at the cell of Friar Lawrence by Arthur Rackham, 1906

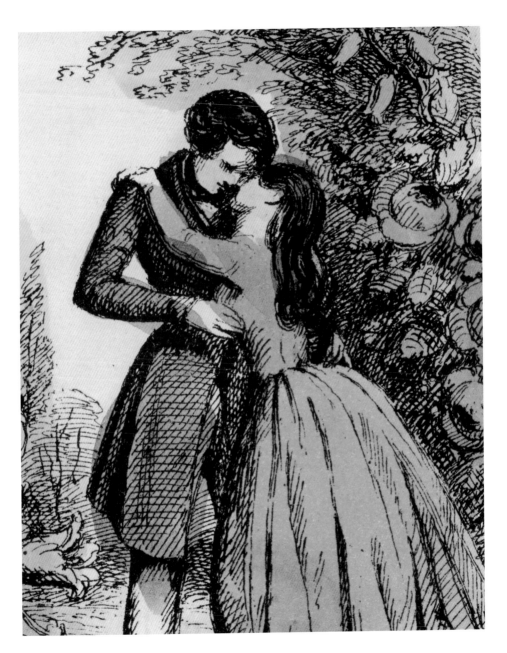

Victorian valentine's card, *c.* 1845–50

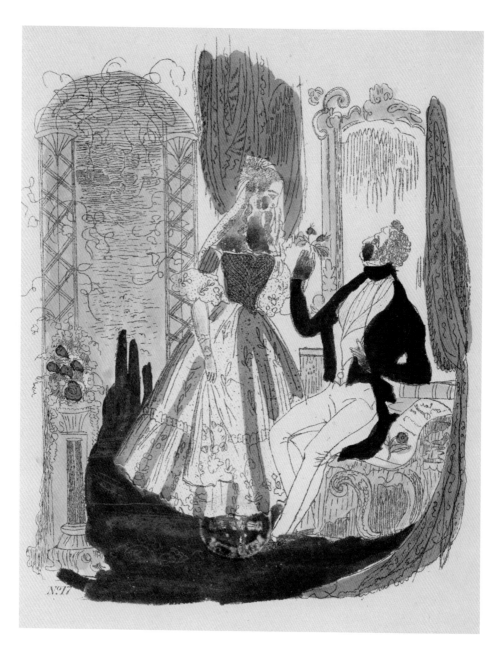

Victorian valentine's card, *c.* 1845–50

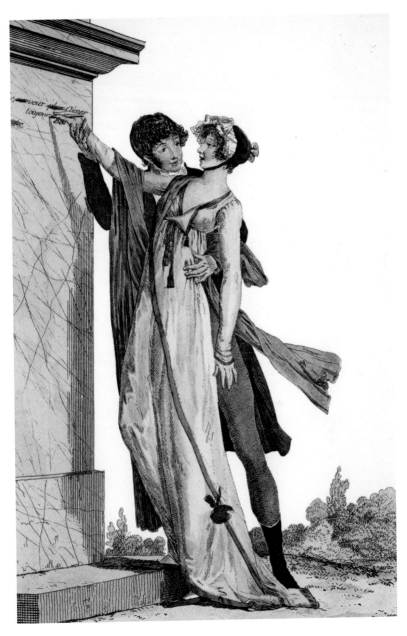

La phrase changée by Philippe-Louis Deboucourt from *Modes et Manières du Jour*, 1798–1808

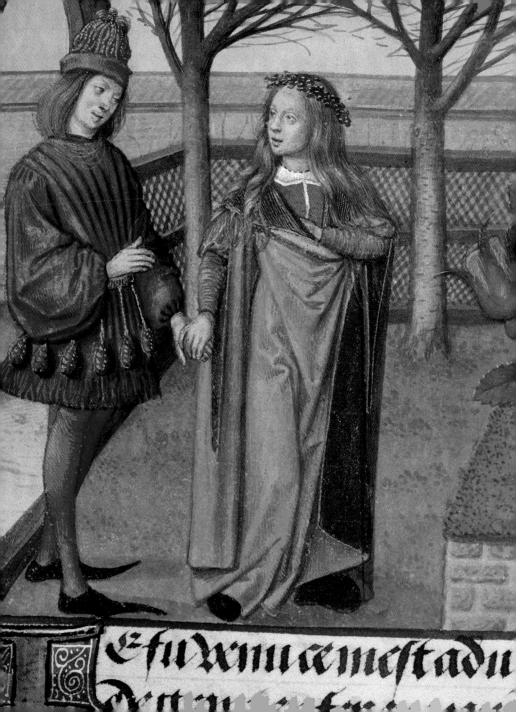

Efu xemu æ meftadu

'We have woven a web you and I,
attached to this world but a separate
world of our own invention.'

John Keats

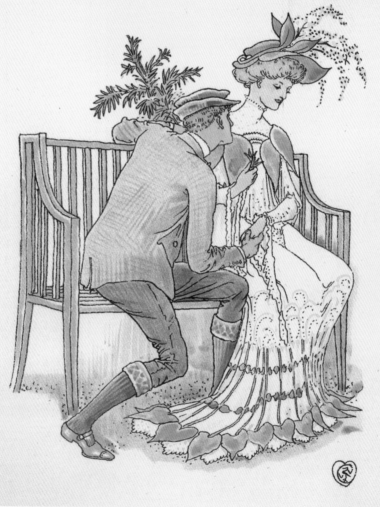

Young LAD'S LOVE had courted Miss Meadow.³
And the two soon agreed at the Altar Sweet,
to meet.

A Flower Wedding by Walter Crane, 1905

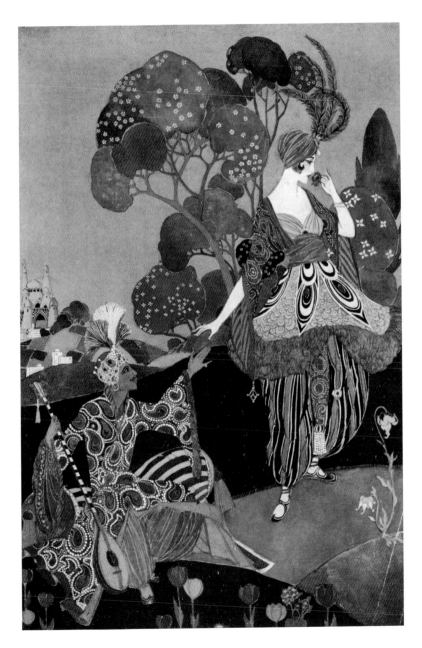

Illustration by Ronald Balfour from the *Rubaiyat of Omar Khayyam*, 1920

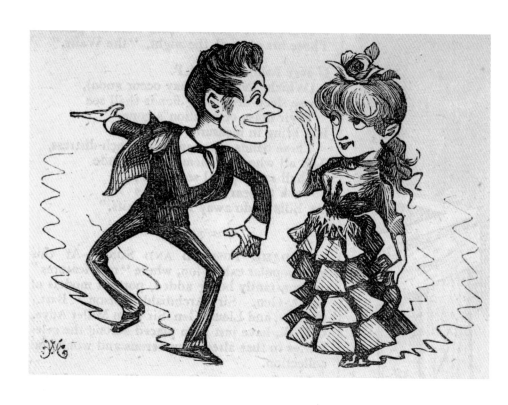

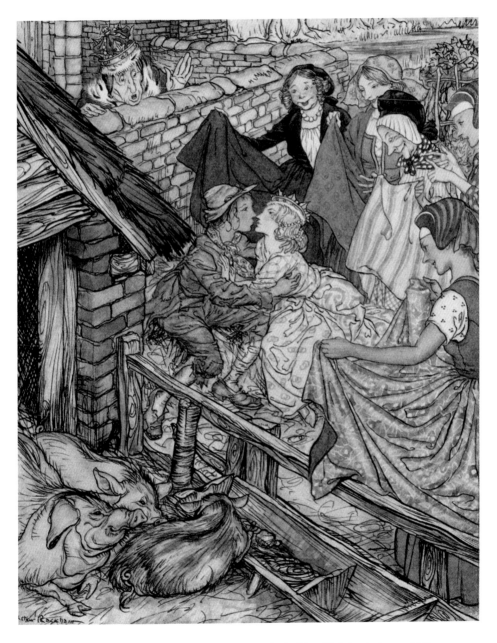

The Swineherd by Arthur Rackham, in *Fairy Tales* by Hans Christian Andersen, 1932

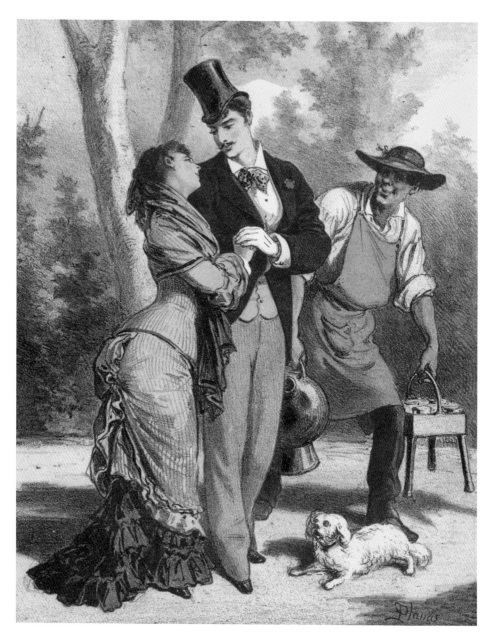

Historia de una mujer (One Woman's Story) by D. Eusabio Planas, 1880s

LOVE-MAKING AT LOWESTOFF

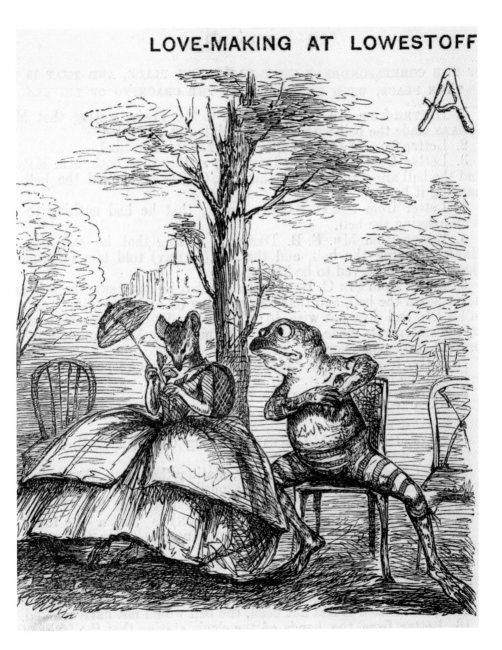

Love-Making at Lowestoft, cartoon from *Punch*, 22 October 1859

'If I had loved you less or played you slyly
I might have held you for a summer more,
But at the cost of words I value highly
And no such summer as the one before.'

Edna St Vincent Millay

Titania and Bottom by Eleanor Fortescue Brickdale, 1919

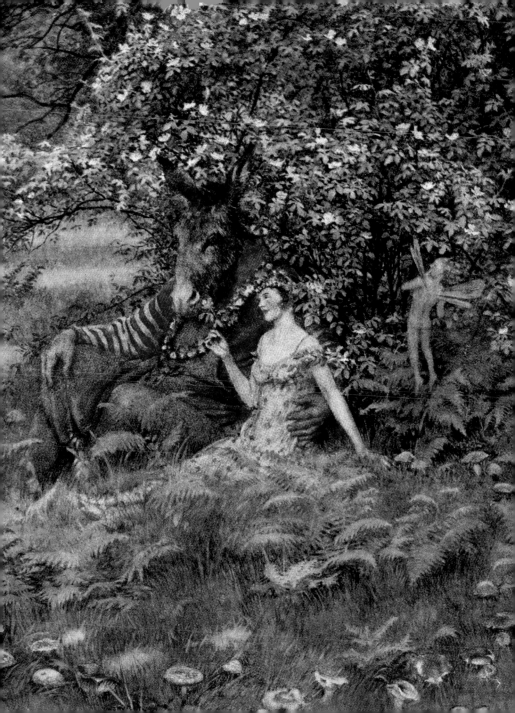

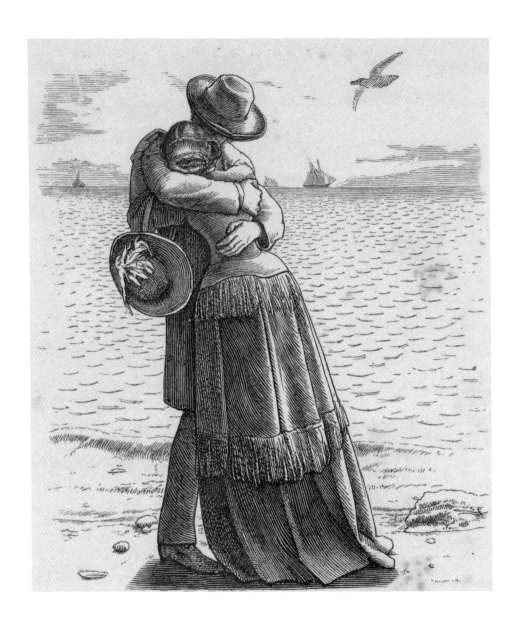

Lockesley Hall by John Everett Millais in *Poems* by Alfred, Lord Tennyson, 1864

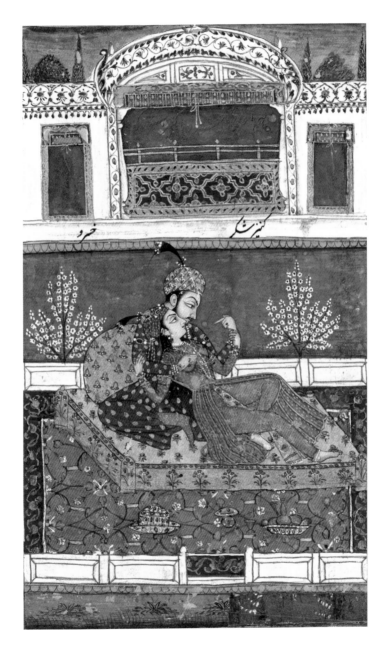

Khusrau flirting with Shakar's companion, 1726

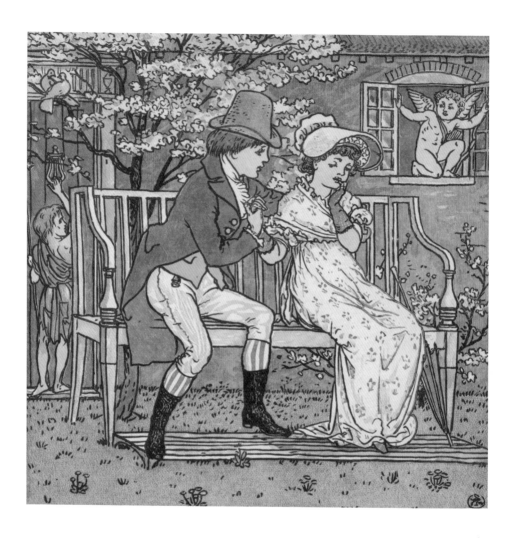

The Baby's Opera by Walter Crane, 1899

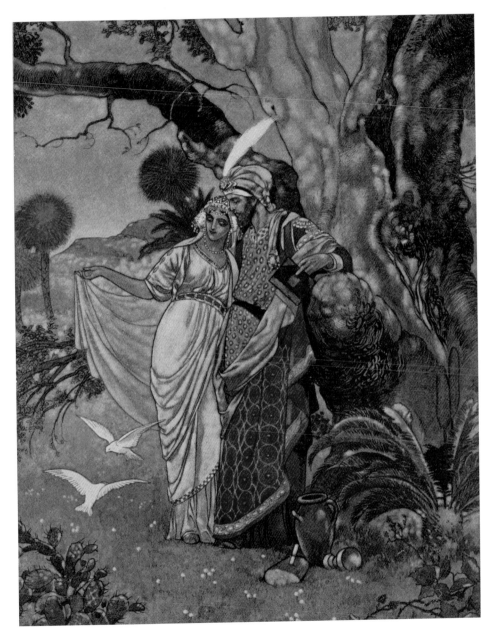

Illustration by Rene Bull from the *Rubaiyat of Omar Khayyam*, 1913

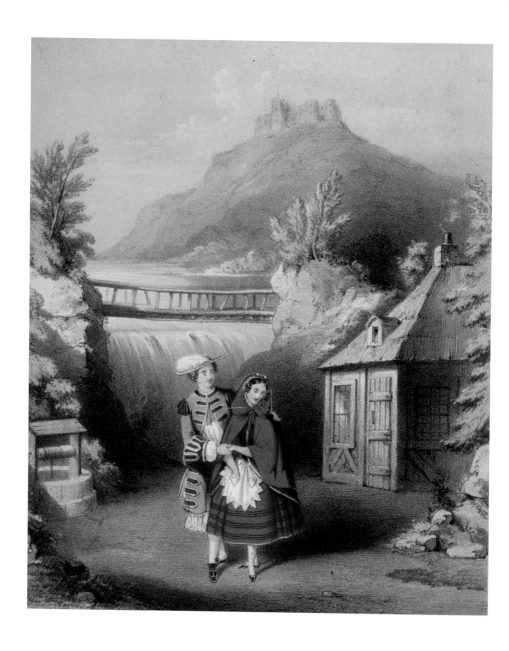

Red Riding Hood Quadrille by Leopold Stern, 1859

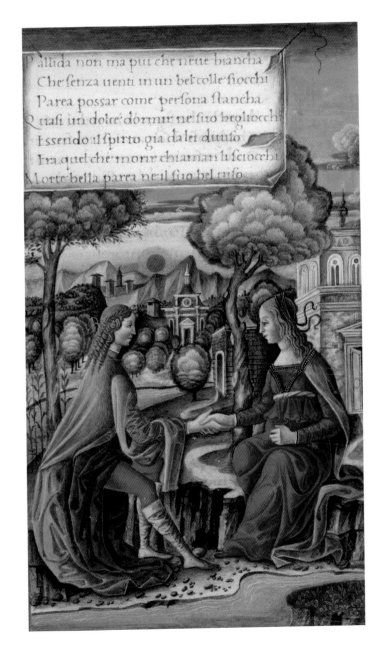

Pallida non ma più che neue biancha
Che senza uenti in un bel colle fiocchi
Parea possar come persona stancha
Quasi un dolce dormir ne suo begliocchi
Essendo il spirto gia da lei diuiso
Era quel che morir chiaman li sciocchi
Morte bella parea ne il suo bel uiso

Fifteenth-century manuscript of Petrarch's poems

75

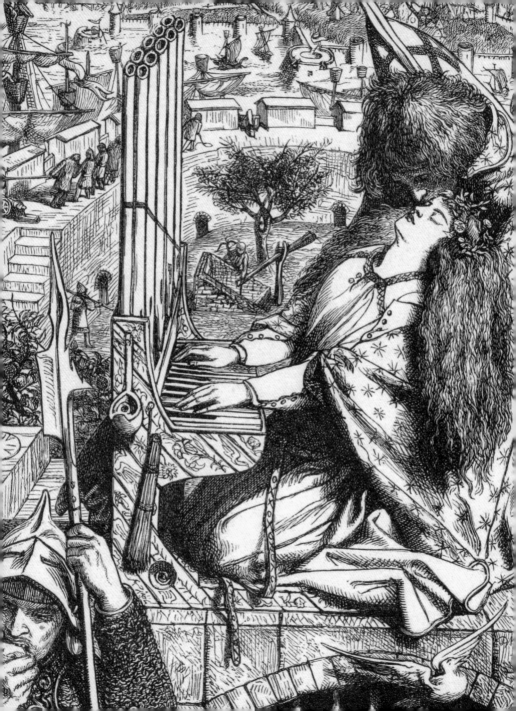

'I love the ground under his feet, and the air over his head, and everything he touches and every word he says. I love all his looks, and all his actions and him entirely and all together.'

Emily Brontë, *Wuthering Heights*

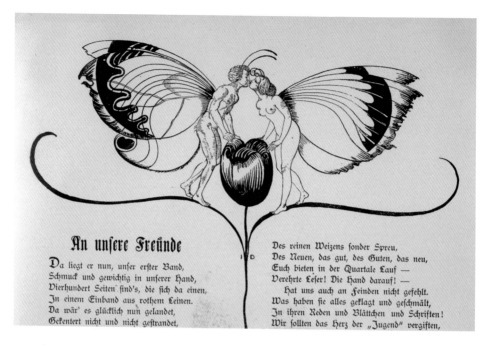

An unsere Freunde

Da liegt er nun, unser erster Band,
Schmuck und gewichtig in unserer Hand,
Vierhundert Seiten sind's, die sich da einen,
In einem Einband aus rothem Leinen.
Da wär' es glücklich nun gelandet,
Gekentert nicht und nicht gestrandet,

Des reinen Weizens sonder Spreu,
Des Neuen, das gut, des Guten, das neu,
Euch bieten in der Quartale Lauf —
Verehrte Leser! Die Hand darauf! —
Hat uns auch an Feinden nicht gefehlt.
Was haben sie alles geklagt und geschmält,
In ihren Reden und Blättchen und Schriften!
Wir sollten das Herz der „Jugend" vergiften,

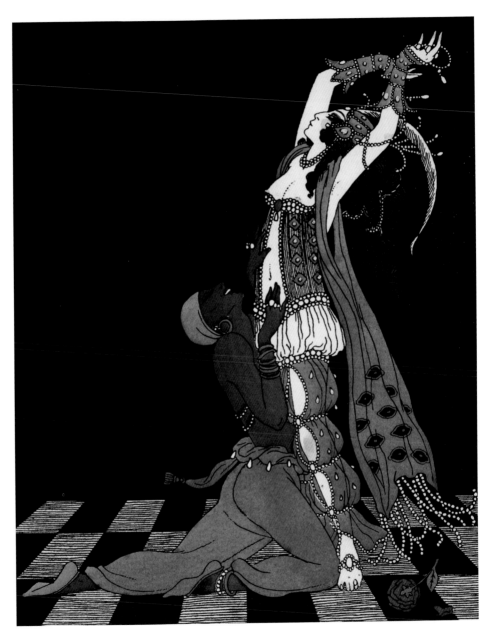

Scheherezade, from *Designs on the Dances of Vaslav Nijinsky* by Georges Barbier, 1913

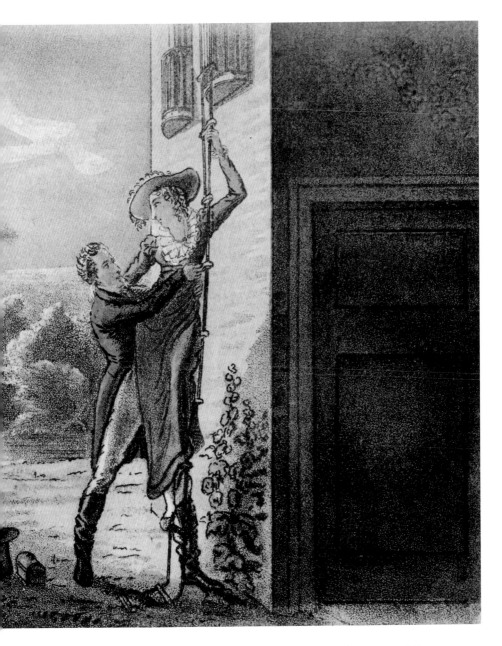

The Elopement by Theodore Lane from *The Life of an Actor* by Pierce Egan, 1892

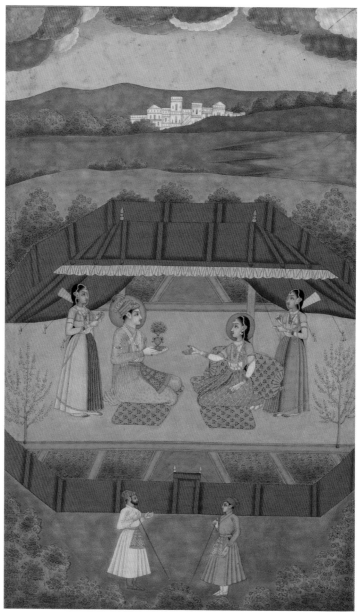

Prince Gauhar and Princess Malika-i Zamani, from *Book of the Affairs of Love*
by Rai Anand Ram Mukhlis, 1734–9

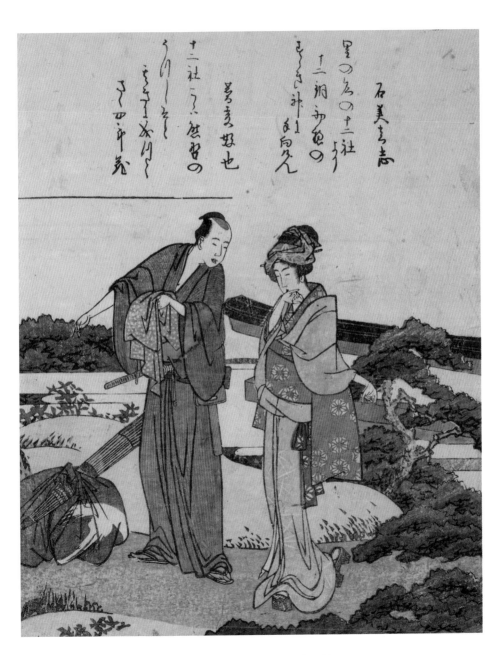

Picture Book of Kyoto by Hokusai, 1804

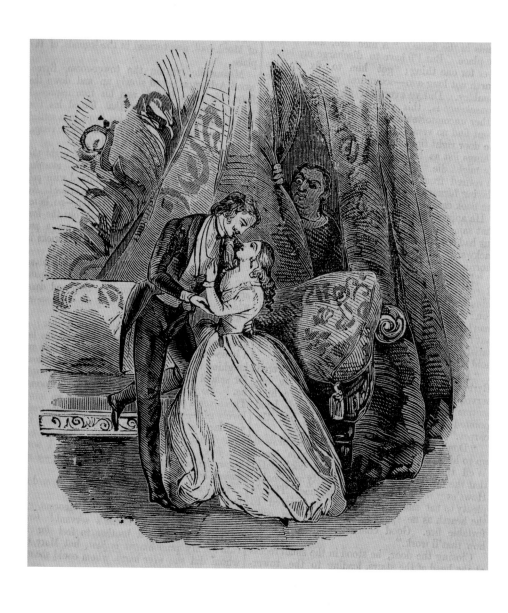

Dora Livingstone, The Adulteress by George Lippard, 1848

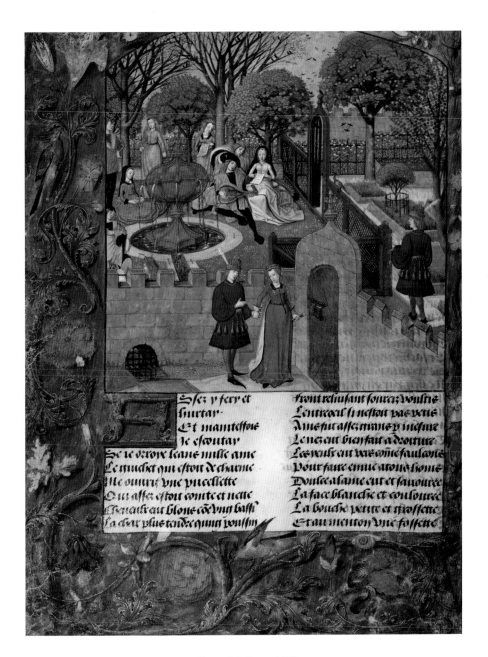

Ssez y fery et
surtay.
Et maintesfois
le escoutay
Se le veroye seane nulle ame
Le truchet qui estoit de charme
Me ouurie vne pucellette
Qui assez estoit comte et nette
Cheueulx eut blons come vng bassi
La chear plus tendre q uing poussin

sront reluisant soura; vousue
Lentreueil si nestoit pas vuie
Ainc pit asseyz crans y inesme
Lenez eut bien fait a droiture
Les yeulx eut vris come saulsaine
Pour faire enuie atoute homme
Doulce alaine eut et sauouree
La face blanche et coulouree
La bouche petite et grossette
Et au menton vne fossette

'I love you as I have never loved any living thing.
From the moment I met you I loved you,
loved you blindingly, adoringly, madly.'

Oscar Wilde, *Lady Windermere's Fan*

Historia de una mujer (One Woman's Story) by D. Eusabio Planas, 1880s

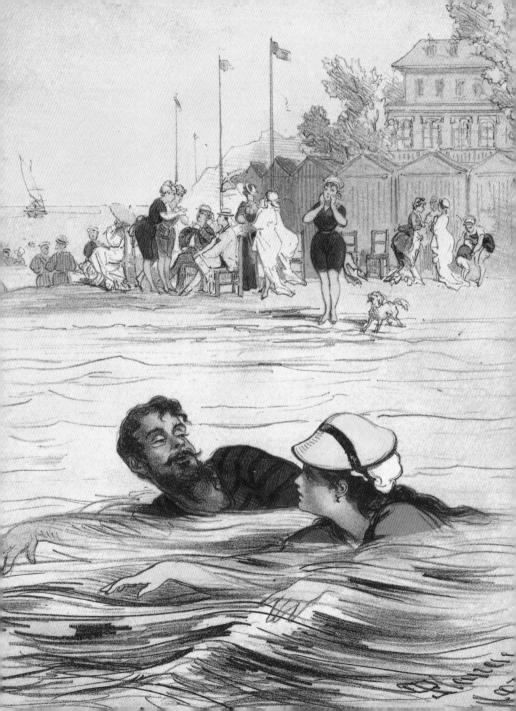

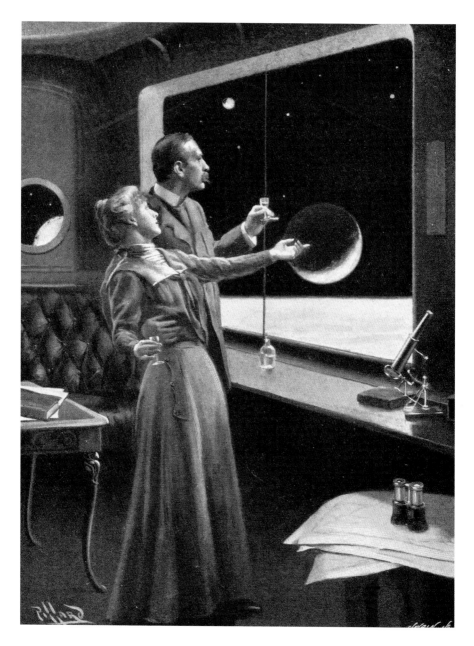

A Honeymoon in Space by George Griffith, 1901

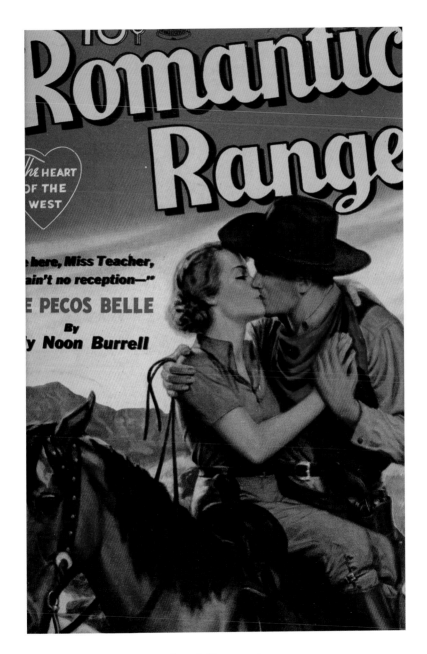

Romantic Range magazine

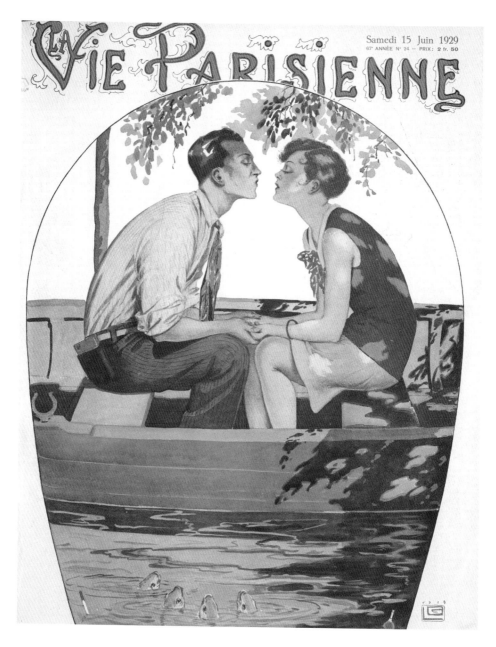

La vie parisienne, 15 June 1929

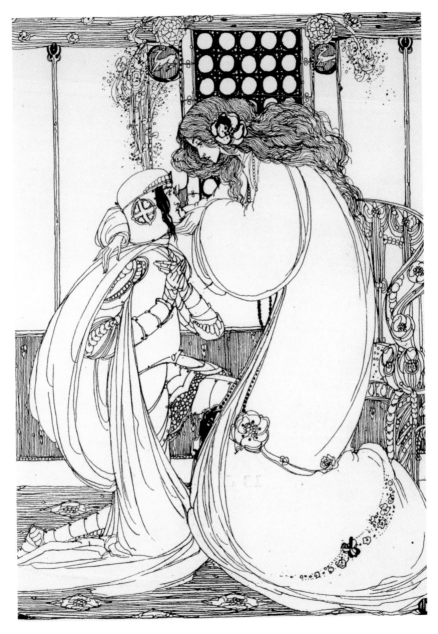

Illustration by Jessie M. King from *The Defence of Guenevere and Other Poems* by William Morris, 1904

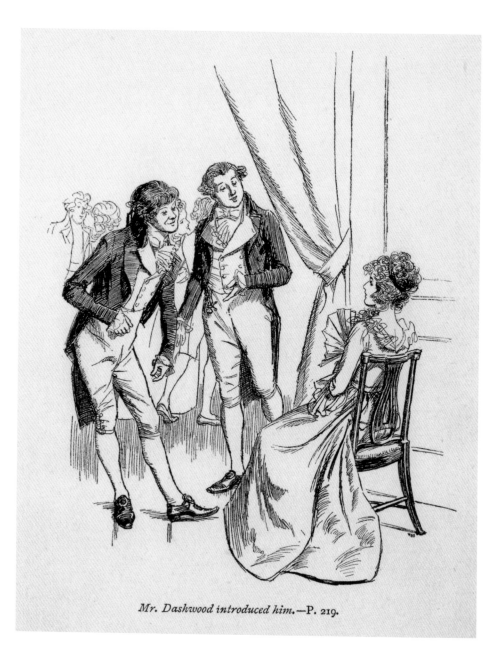

Mr. Dashwood introduced him. —P. 219.

Illustration by Hugh Thomson from *Sense and Sensibility* by Jane Austen, 1896

THE
CARRYING

THE
MERRY-
-MAKING
O!

AND

Randolph Caldecott's *Graphic Pictures*, 1889

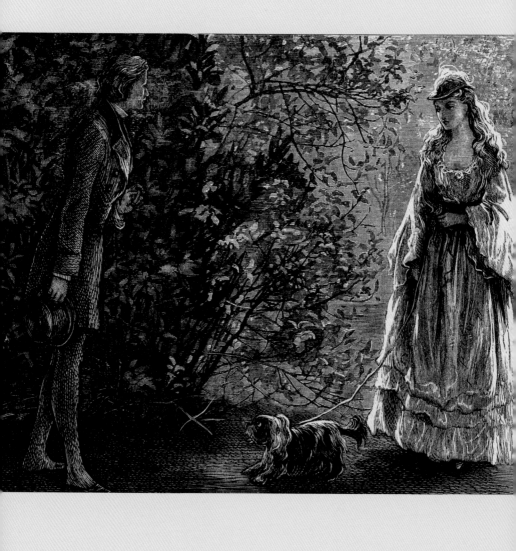

'If I may so express it, I was steeped in Dora.
I was not merely over head and ears in love with her,
but I was saturated through and through.'

Charles Dickens, *David Copperfield*

David Copperfield and Dora by Fred Barnard, 1871–80

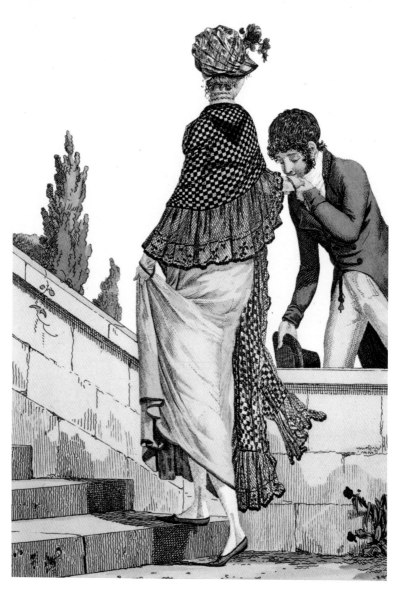

A ce soir by Philippe-Louis Deboucourt from *Modes et Manières du Jour*, 1798–1808

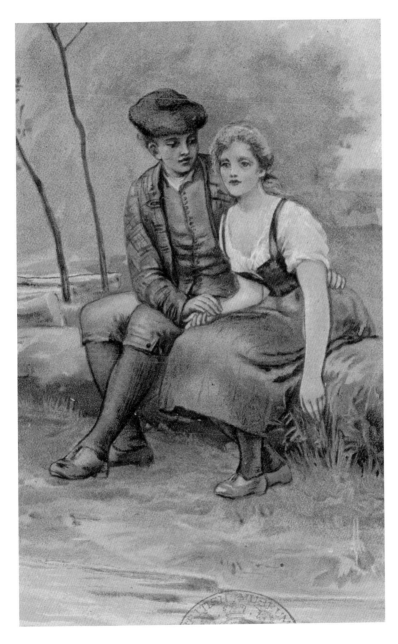

Auld Lang Syne by George Harvey, 1905

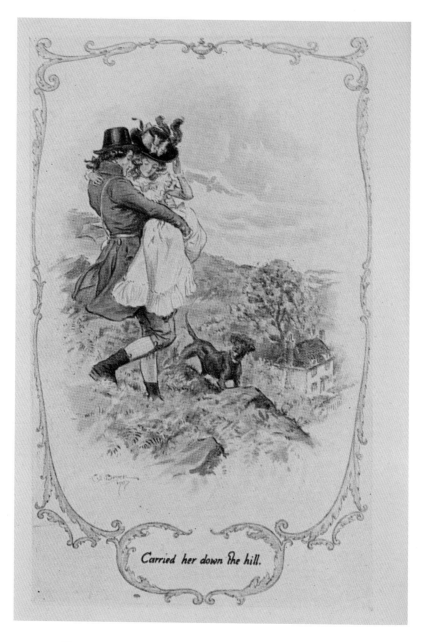

Carried her down the hill.

Illustration by C. E. Brock from *Sense and Sensibility* by Jane Austen, 1908

A Humble Romance and Other Stories by Mary E. Wilkins, 1893

'Her heart is given him, with all its love and truth.
She would joyfully die with him, or better
than that, die for him.'

Charles Dickens, ***Our Mutual Friend***

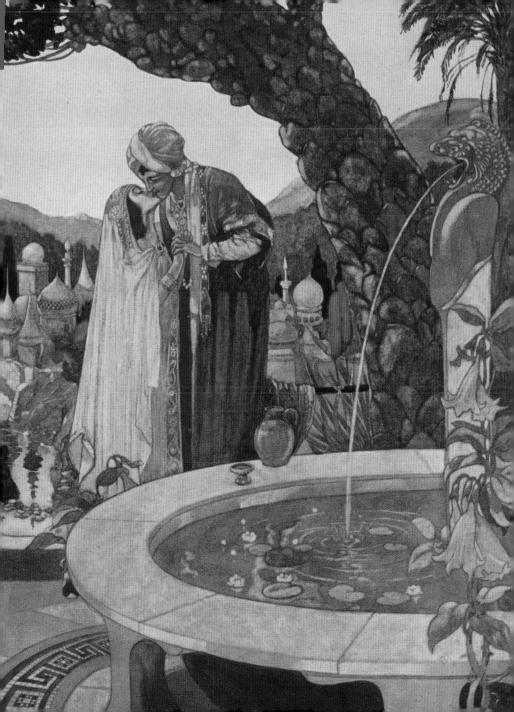

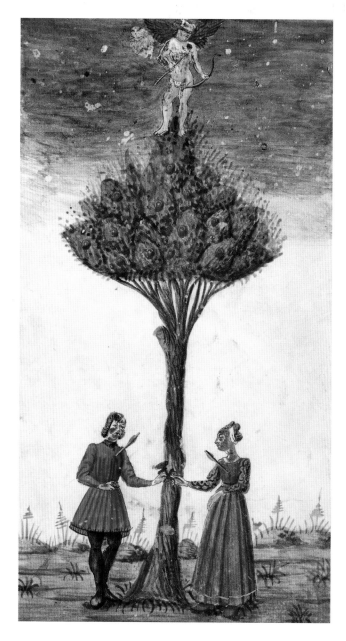

Fifteenth-century Italian manuscript of Ovid's *Ars Amatoria*

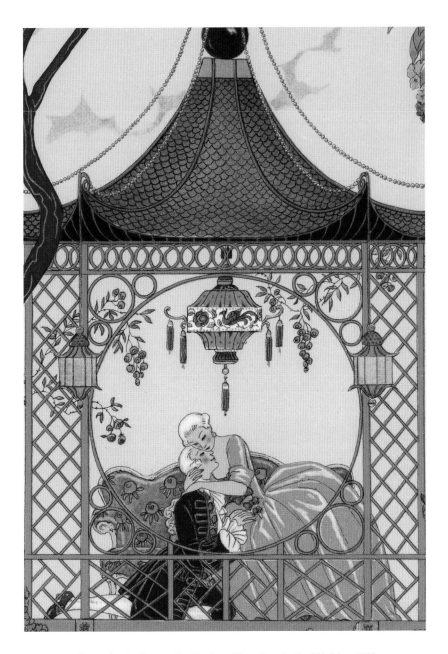

Illustration by Georges Barbier from *Fêtes galantes* by Paul Verlaine, 1928

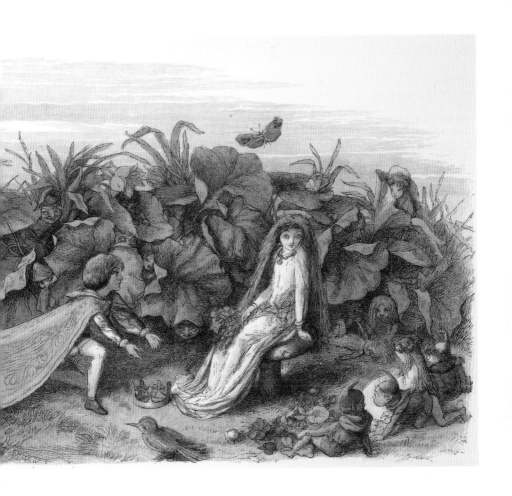

In Fairy Land: A Series of Pictures from the Elf-World by Richard Doyle, 1870

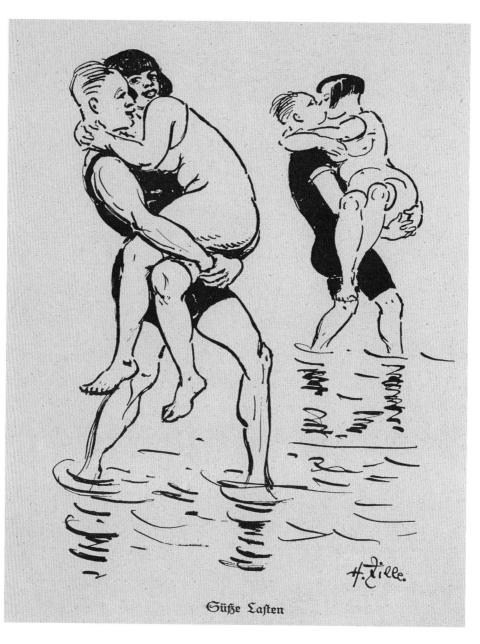

Süße Lasten

Rund ums Freibad by Heinrich Zille, 1926

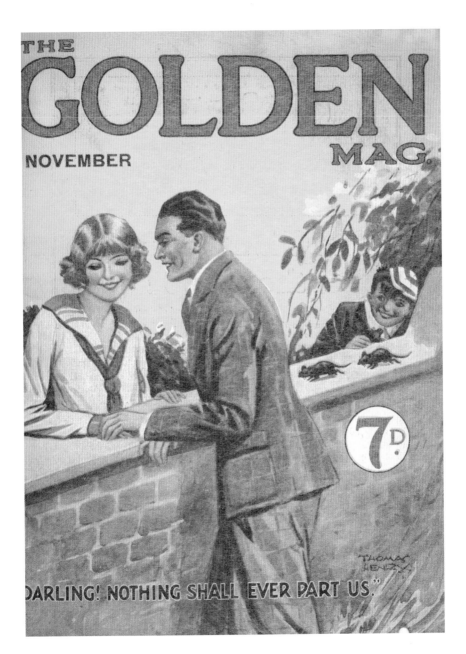

Just William in *The Golden Magazine*, November 1926

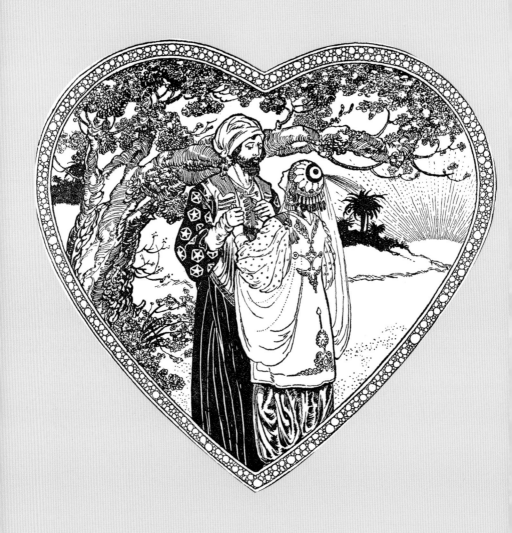

'We need in love to practise only this: letting each other go. For holding on comes easily; we do not need to learn it.'

Rainer Maria Rilke

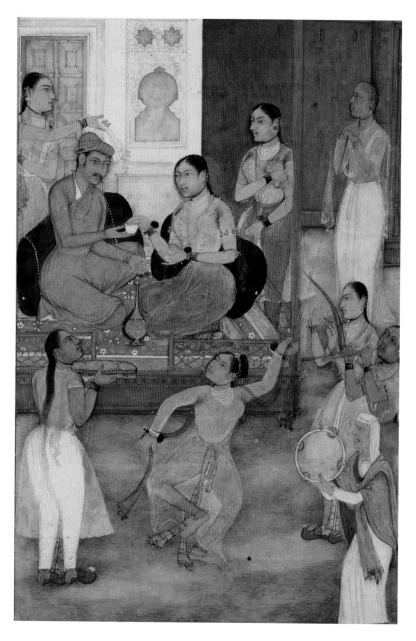

Sultan of Baghdada and a Chinese slave girl, from *Lights of Canopus* by Husain Vaiz al-Kashifi, 1604–5

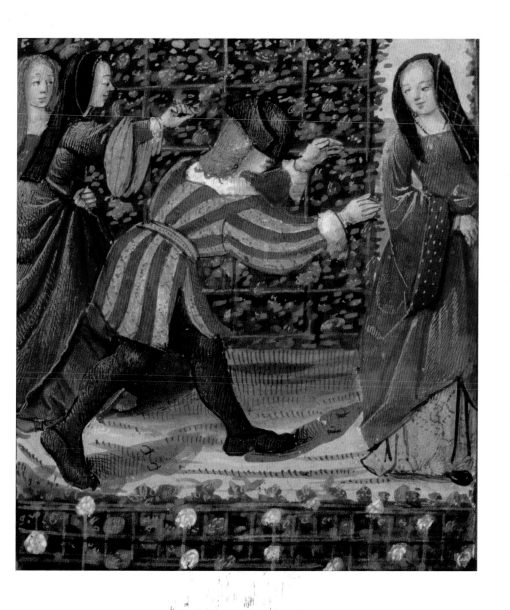

A game of blind man's buff in Pierre Sala's *Petit Livre d'Amour*, sixteenth century

Troilus and Cressida by Eric Gill, 1931

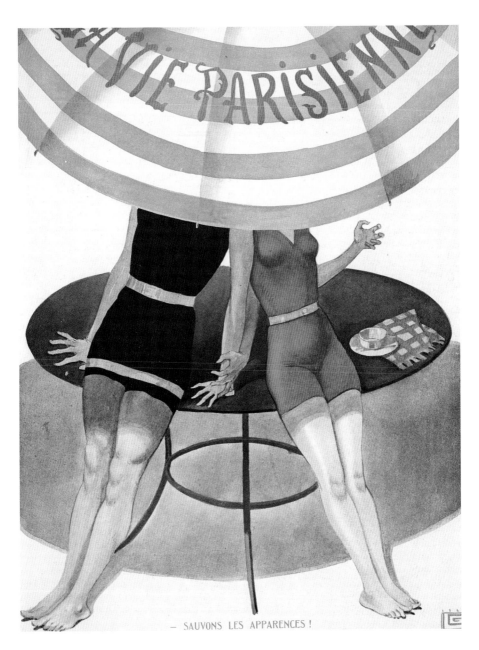

La vie parisienne, 15 June 1929

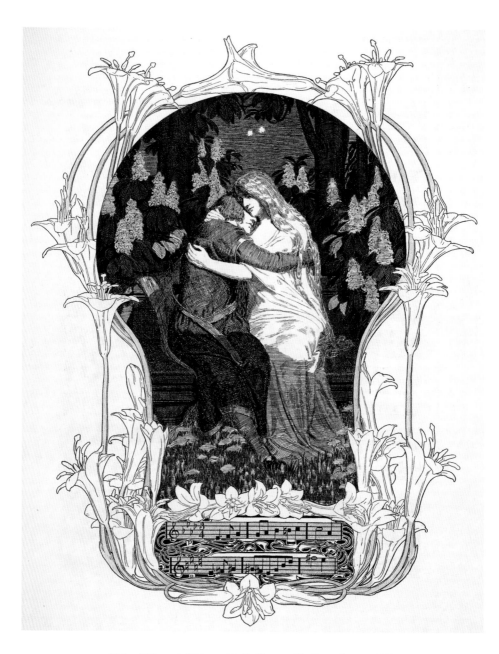

Richard Wagner's *Tristan and Isolde*, illustrated by Franz Stassen, 1880

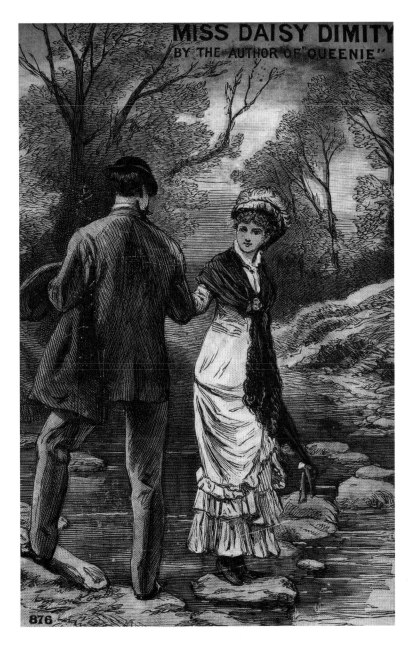

Miss Daisy Dimity by Maria Henrietta de la Cherois Crommelin, 1881

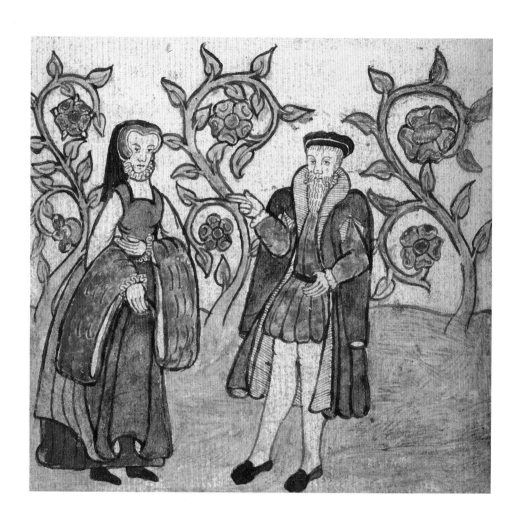

Robert the Devil, Romance poem, *c.* 1564

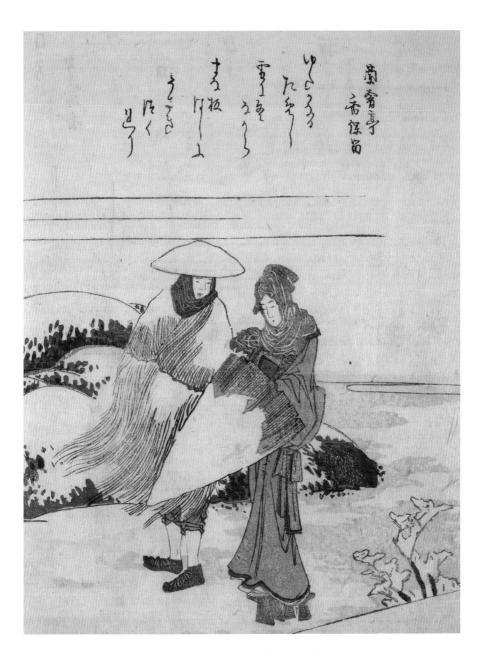

Picture Book of Kyoto by Hokusai, 1804

117

'Love is like quicksilver in the hand.
Leave the fingers open and it stays.
Clutch it and it darts away.'

Dorothy Parker

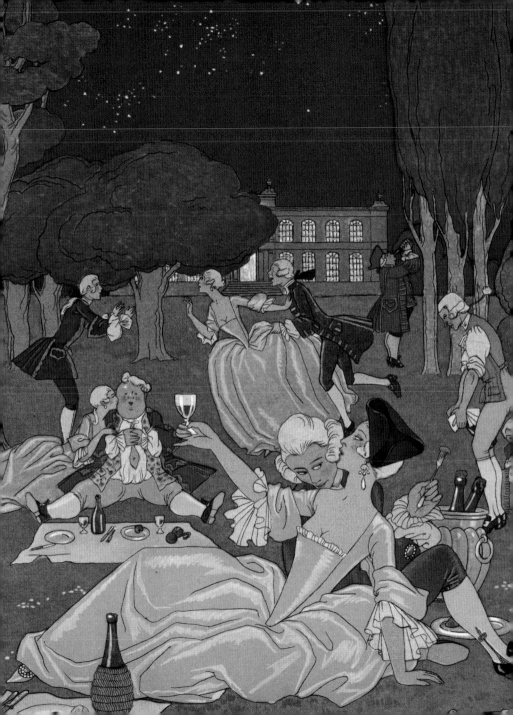

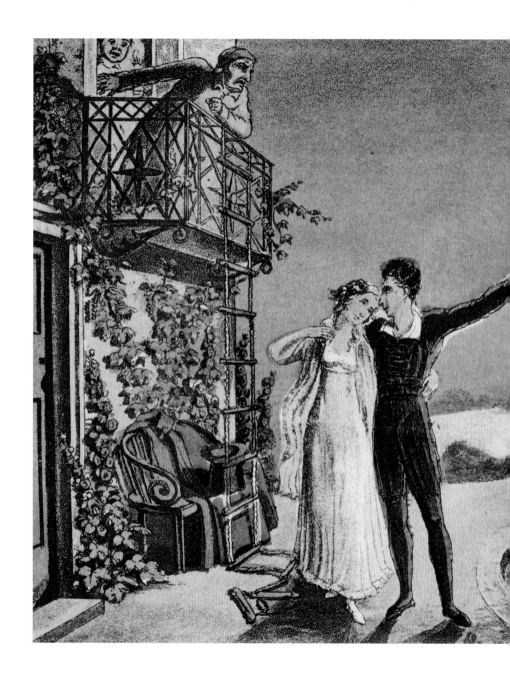

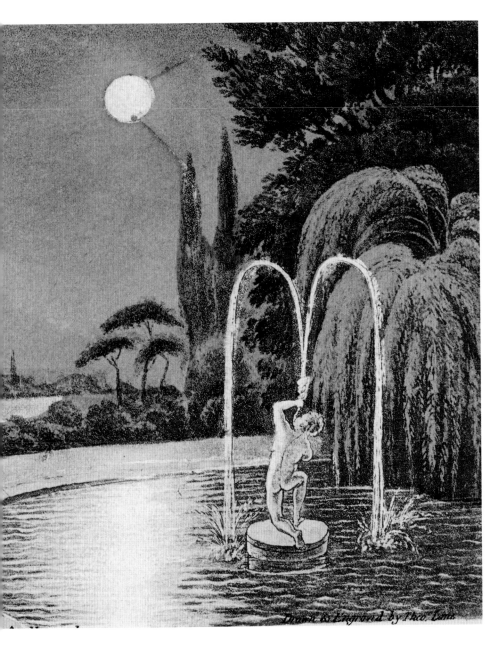

Proteus in Love by Theodore Lane from *The Life of an Actor* by Pierce Egan

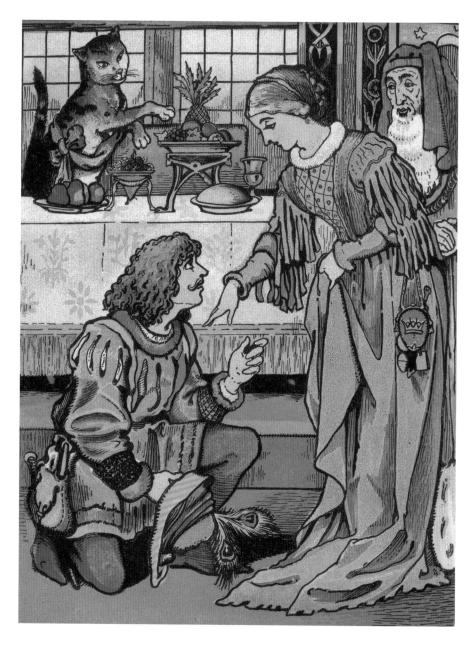

Puss in Boots, 1877

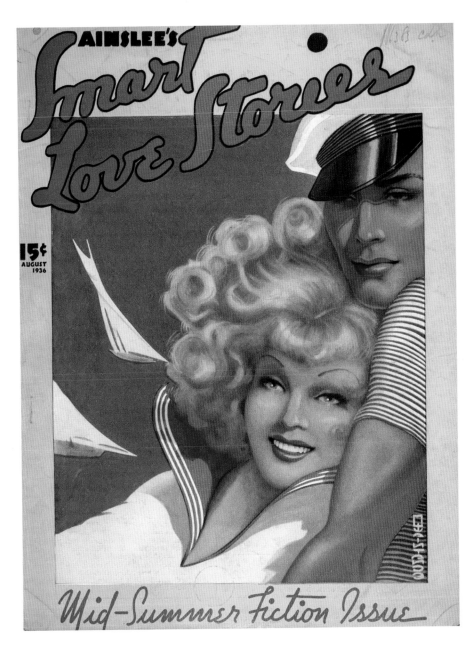

Smart Love Stories, August 1936

Pantone advert, 1931

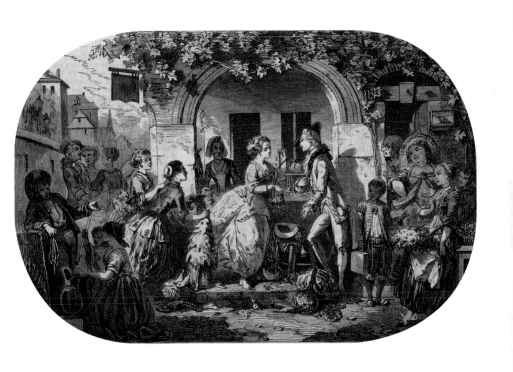

L'Illustration, 18 June 1853

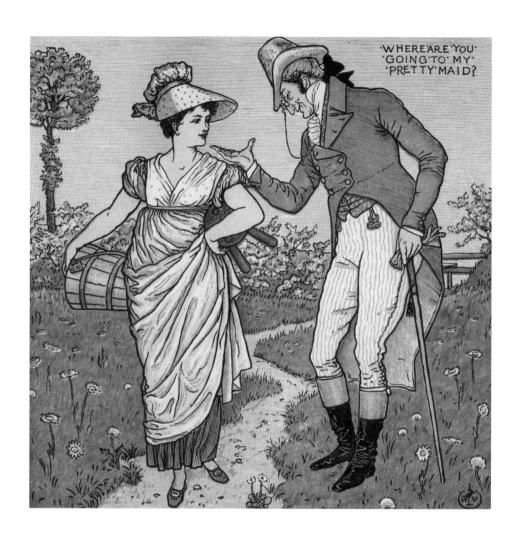

The Baby's Opera by Walter Crane, 1899

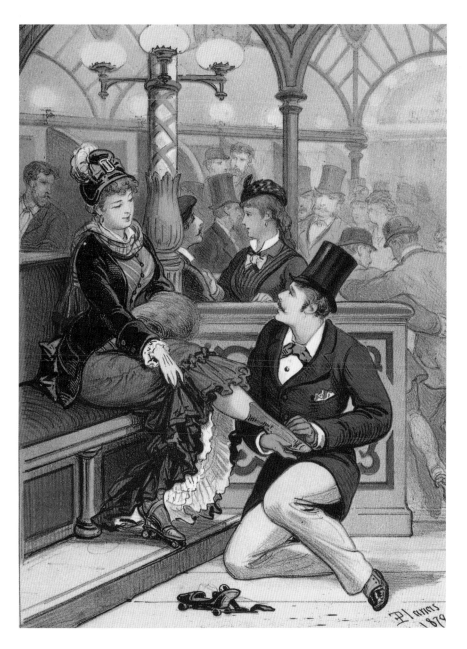

Historia de una mujer (One Woman's Story) by D. Eusabio Planas, 1880s

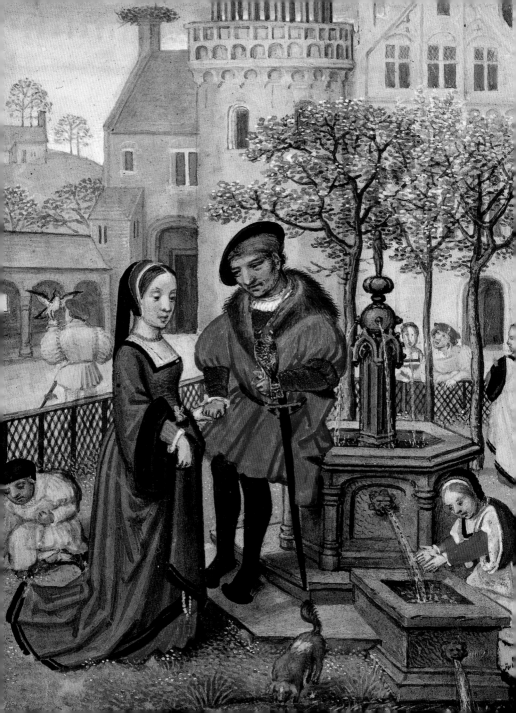

'Believe in a love that is being stored up for you like an inheritance, and have faith that in this love there is a strength and a blessing so large that you can travel as far as you wish without having to step outside it.'

Rainer Maria Rilke

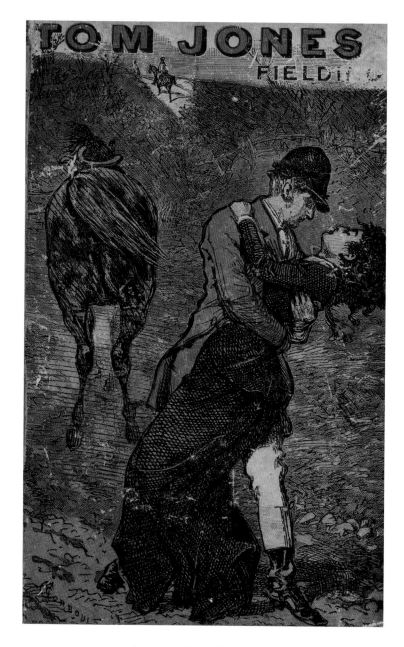

Tom Jones by Henry Fielding, 1867

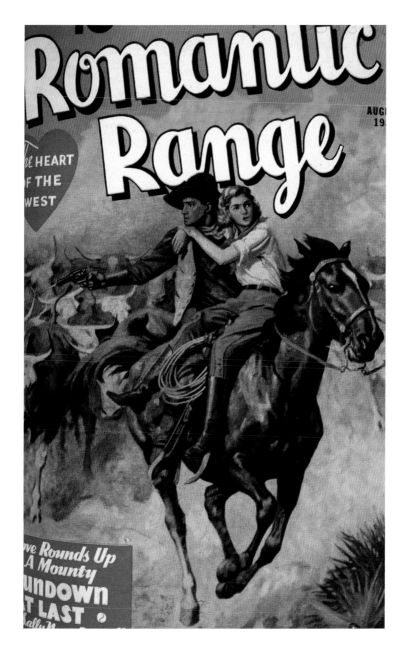

Romantic Range magazine, August 1936

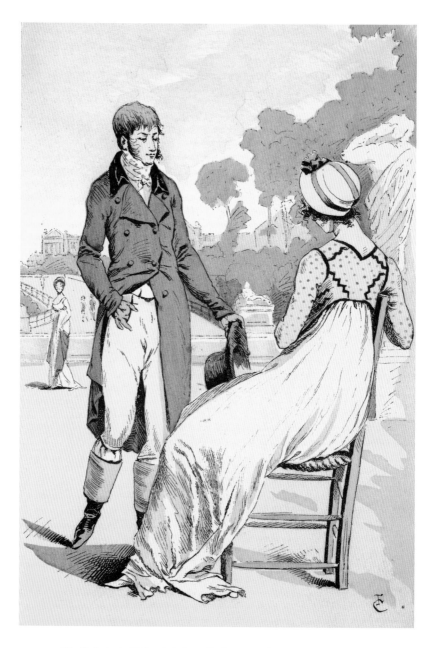

The Tuileries by F. Courboin from *Fashion in Paris* by Octave Uzanne, 1898

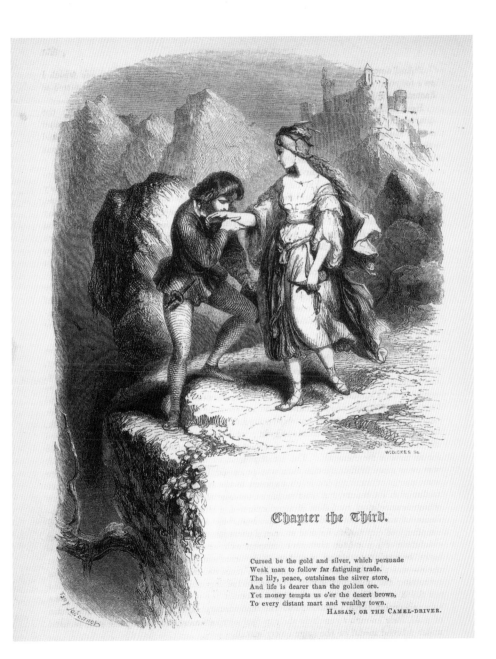

Chapter the Third.

Cursed be the gold and silver, which persuade
Weak man to follow far fatiguing trade.
The lily, peace, outshines the silver store,
And life is dearer than the golden ore.
Yet money tempts us o'er the desert brown,
To every distant mart and wealthy town.

HASSAN, OR THE CAMEL-DRIVER.

Illustration by Daniel Maclise in *Irish Melodies* by Thomas Moore, 1846

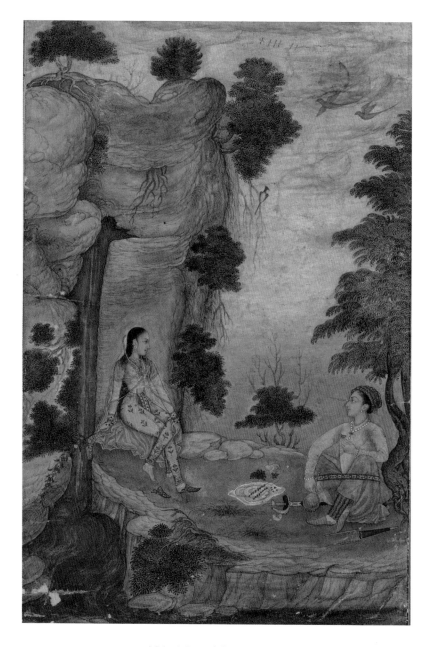

A Princely Romantic Interlude, c. 1630

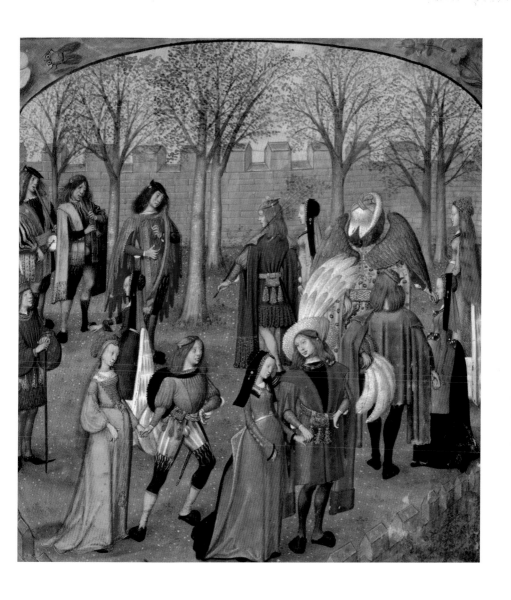

Roman de la Rose, c. 1490

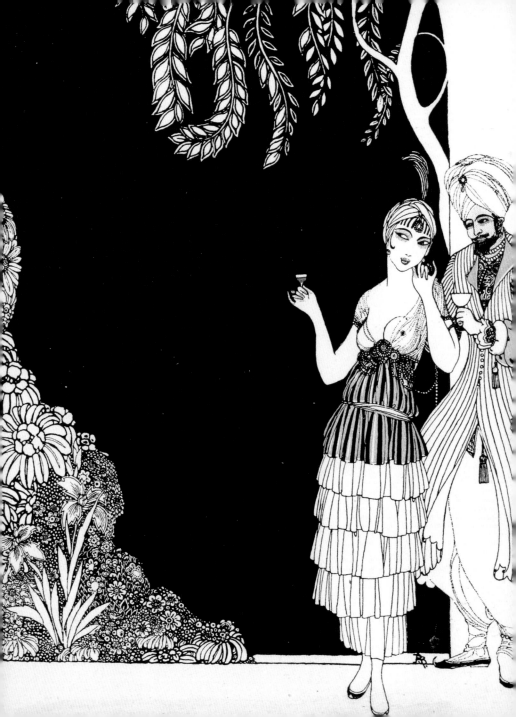

'Morning without you is a dwindled dawn.'

Emily Dickinson

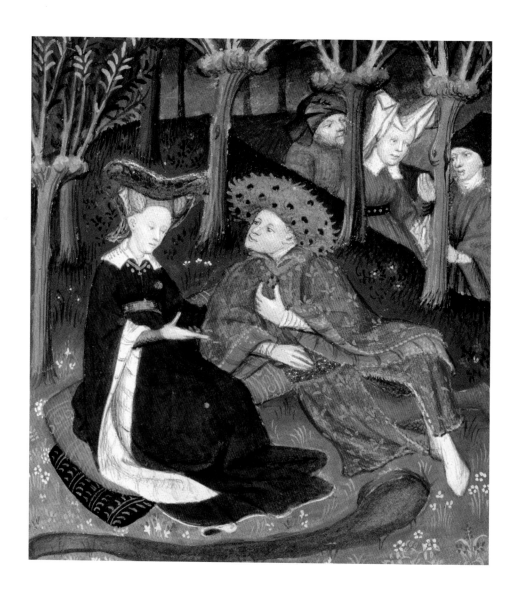

The Book of the Queen by Christine de Pisan, *c.* 1410–14

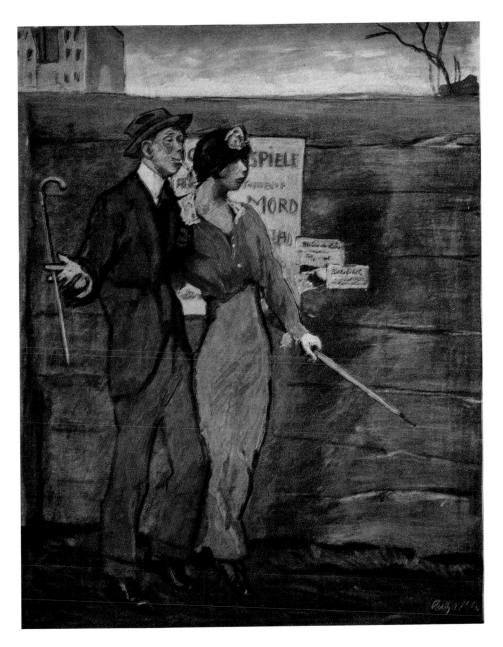

Jugend magazine, 1904

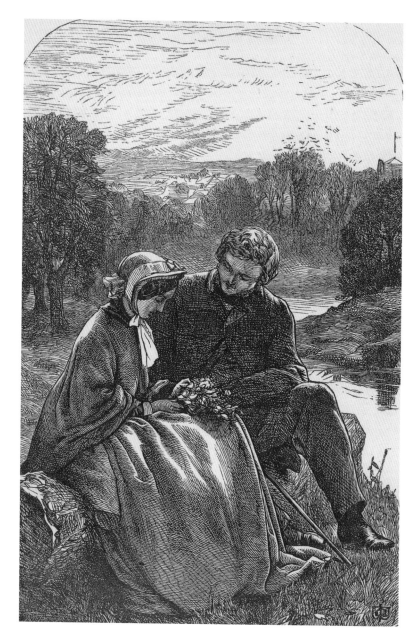

Through Life and For Life by D. Richmond, 1862

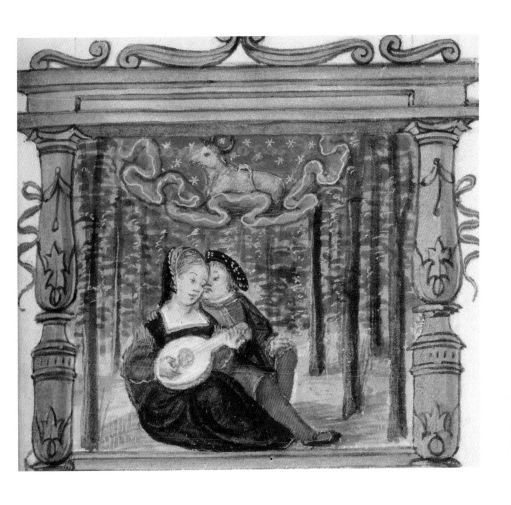

Hours of the Virgin, sixteenth-century manuscript

'I'll tell you,' she said in the same hurried passionate whisper, 'what real love is. It is blind devotion, unquestioning self-humiliation, utter submission, trust ... giving up your whole soul to the smiter – as I did.'

Charles Dickens, *Great Expectations*

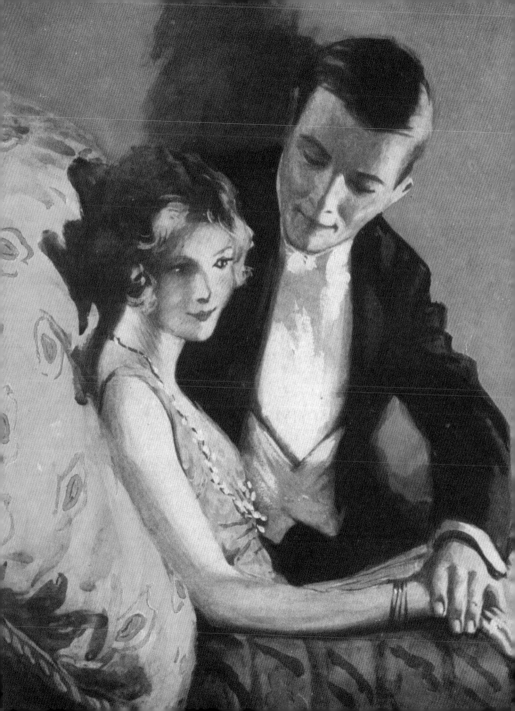

First published in 2014 by
The British Library
96 Euston Road
London NW1 2DB

British Library Cataloguing in Publication data
A catalogue record for this publication is available
from the British Library

ISBN 978 0 7123 5719 7

Images © The British Library 2014

Frontispiece: *La vie parisienne* magazine, 31 July 1926

Designed by Goldust Design
Printed in Hong Kong by Great Wall Printing Co. Ltd